legends ²

legends²

WOMEN WHO HAVE CHANGED THE WORLD
THROUGH THE EYES OF GREAT WOMEN WRITERS

EDITED BY JOHN AND KIRSTEN MILLER

NEW WORLD LIBRARY
NOVATO, CALIFORNIA

New World Library
14 Pamaron Way
Novato, CA 94949

For permissions acknowledgments, see page 125.

Copyright © 2004 by John and Kirsten Miller
Cover and interior design by John Miller/Miller Media

Library of Congress Cataloging-in-Publication Data
Legends 2 : women who have changed the world through the eyes of great women
writers / edited by John and Kirsten Miller.

 p. cm.
ISBN 1-57731-439-5 (hardcover : alk. paper)
1. Women—Biography. 2. Biography—20th century. 3. Biography—21st
century. I. Title: Legends two. II. Miller, John, 1959– III. Miller, Kirsten, 1963–

 CT3235.L44 2004

 920.72'09'045—dc22 2004006017

First printing, October 2004
Hardcover edition ISBN 1-57731-439-5
Paperback edition ISBN 1-57731-501-4
Printed in Korea
Distributed to the trade by Publishers Group West

10 9 8 7 6 5 4 3 2 1

Special thanks to Amy Rennert, Jason Gardner, Munro Magruder,
Seaneric Hachey, and Aaron Kenedi

contents

introduction

IN OUR FIRST ANTHOLOGY, *Legends*, we collected profiles of legendary women who had made an indelible impression on the twentieth century, women with secure positions in the history books. In *Legends²* our focus has changed slightly. The book includes profiles of women already recognized as legendary—Janis Joplin, Zelda Fitzgerald, and Maria Callas among them—but we've also taken on a risk: looking around at today's politicians, movie stars, writers, musicians—the public women we love, right now—and trying to predict whose legacies will last.

Of course, it's not *that* much of a risk. Students will be marveling at Nobel laureate Toni Morrison's fiction far into the coming centuries. Hillary Clinton, whose political career has already made history, will continue to surprise and inspire in upcoming elections. Women's tennis will most likely never again witness a sibling rivalry as fierce as that of champions Venus and Serena Williams. And Diane Keaton's wonderfully unique and peculiar performances have earned her a lasting place among film's true originals.

These are women who fascinate and inspire, women who have broken down barriers and stood on the shoulders of barrier-breakers before them to accomplish the previously unimaginable. As in our first book, women writers—some famous, some lesser known—are paired with great photographers to reveal intimate portraits of these modern icons. Their profiles were written at various times—some are up to date; others are glimpses of recent history. When an update was necessary, we listed significant events in the biographies in the back of the book.

The women in these pages have had a profound impact on all of us. They entertain us, educate us, and shape the world we live in. We hope you enjoy *Legends²* as much as we enjoyed producing it.

John and Kirsten Miller

venus and serena williams

BY ANDREA LEAND

IT'S 7:00 A.M. IN PALM BEACH GARDENS, Florida, and as usual, Venus and Serena Williams are practicing on one of two clay courts on their family's 10.6-acre estate. Serena is scrambling for every ball hit by her sister Venus. Venus glides toward the net and hits a winner, just out of the reach of a frustrated Serena, who then refuses to pick up nearby balls in preparation for the next point. Instead, she casually stares at her racket strings. Venus just shrugs and retrieves the balls herself.

"There's definitely a competitiveness between Serena and Venus," says former U.S. Open finalist Pam Shriver. "They motivate each other and feed off each other's successes."

The world of tennis may find it hard to keep up with this talented sister act. But then, it's been that way since Venus began playing on the neighborhood courts of Compton, California, at age four and was called a "ghetto Cinderella" by her father, Richard. By nine, she was a tennis prodigy who went on to win sixty consecutive junior matches. Two years later, Venus's father bucked the system and plucked his daughters from junior competition so that they could refine their games and attend high school on a normal schedule. But even after Venus and Serena turned pro, Richard limited their tournament schedules so they could graduate private school on time.

"Venus and Serena are closer to balanced than any other players in pro tennis," Richard says. "I don't push them at all about practicing, so they can never tell me later, 'you made me do this.'"

Off the court, the sisters' personalities are as different as their pet dogs, Star, a floppy-eared brown puppy, and Queen, a Dalmatian. "Star is like me," says Serena. "She's built with thick legs and is very determined. Queen has the skinny legs like Venus and is the better thinker."

The contrasts don't end there. Serena is more gregarious then her sister. Once, Serena shouted to U.S. Open champion Patrick Rafter, "Hey, lover boy," and jumped into a photo shoot with French Open champion Gustavo Kuerten. Venus? She stayed in her hotel room reading poetry.

Being the older sister has its rewards. "I'm able to make better decisions than Serena," Venus says. "I'm able to think things through more. Once when our golf cart caught fire, Serena wanted to run, but I stayed and put dirt on the fire to put it out."

"But the better we get, the tougher it gets," Serena adds. "We're good players and just have to go at it and do what we can. But I like us being considered a team, because then there's no pressure, no pain on me."

"And then, if either of us does well," Venus says, "it's success for both of us."

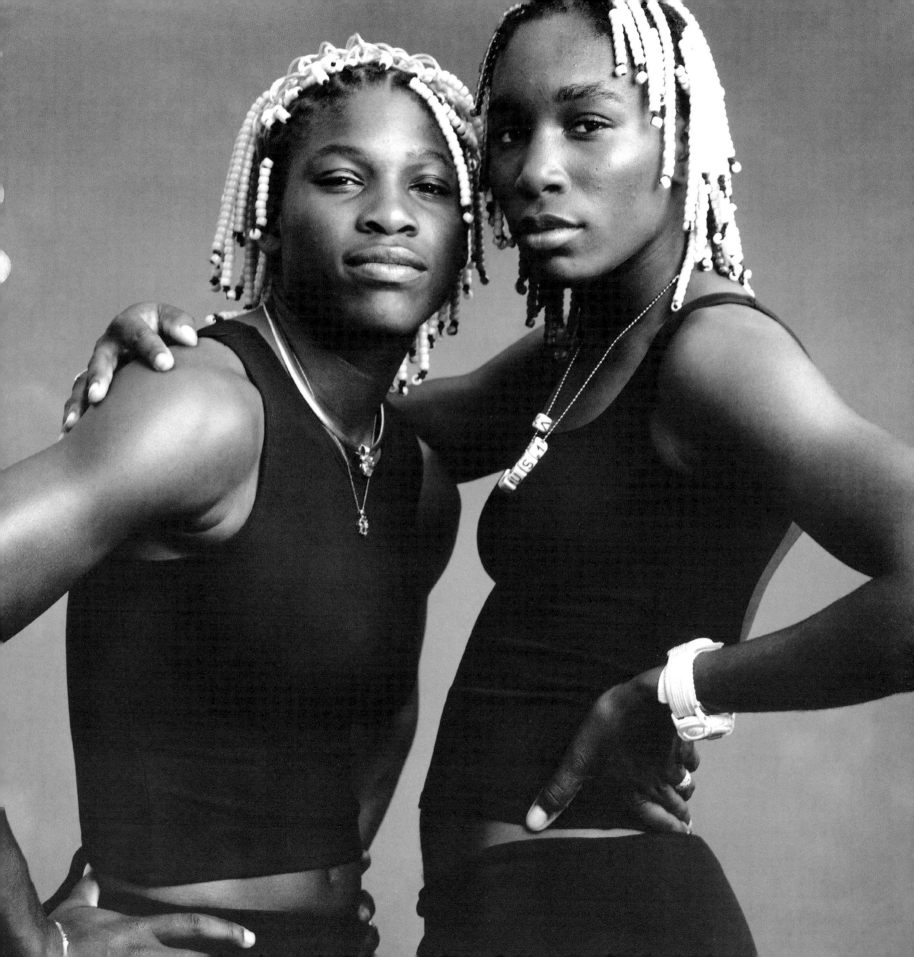

vera wang

BY LYNDA RICHARDSON

VERA WANG REVOLUTIONIZED HOW WOMEN LOOK on one of their biggest days, making brides reconsider lacy froufrou getups in favor of something stylish and spare, even sexy. Think of the hot numbers worn by celebrity brides like Sharon Stone, Uma Thurman, and Mariah Carey. Wang has just finished back-to-back collections of bridal and evening wear, and she's preparing new collections of shoes, handbags, and eyewear, as well as crystal and china.

Wang's design room is quite a magical place. There are racks upon racks of bridal gowns, some strapless or with dropped waists, crystal beads, and floral appliqués. On the floor are tulle hats and bolts of fabrics. Her gown sketches are tacked to the walls.

Ms. Wang is in her element here. She has a surprisingly loud voice and simply commands the floor, even when she sits, one leg tucked underneath her. It's clear she's one of those focused multitaskers. She says she's got to be. There's a staff of two hundred fifty employees to whom she's expected to be "a superwoman at all times." And there's also family: her investment banker husband, Arthur Becker, and their two daughters, Josephine and Cecilia, whom the couple adopted as infants. They live in a Park Avenue apartment.

A search for a dress for her own 1989 wedding inspired her to create her company. "I didn't see anything that was my own sense of modernity." She had spent the previous sixteen years as a fashion editor and stylist for *Vogue* magazine and as a design director for accessories at Ralph Lauren.

She grew up in a wealthy family on the Upper East Side. Her parents had fled China in the 1940s, building a multimillion-dollar trading and pharmaceuticals company after emigrating to the United States. Ms. Wang, one of two children, has led a glamorous life. As a teenager, she was a competitive skater, making the cover of *Paris Match* at age nineteen with her boyfriend, the French Olympic skating champion. She studied at the School of American Ballet in New York and graduated from Sarah Lawrence College after spending a year at the Sorbonne. She boogied all night at Studio 54.

"I've lived a very way-out-there life," she says. "I've lived through Elvis, no TV, through TV, cellphones, hippies, marches, '70s disco, cocaine fever, through the yuppies and the age of computers. It's been a wild ride."

A White House state dinner with her good friends the Clintons three years ago was one big moment. "One day I'm sitting at Penn Station eating a hot dog at Nathan's, trying to catch the Metroliner," she says, "and the next day I'm meeting the president of China."

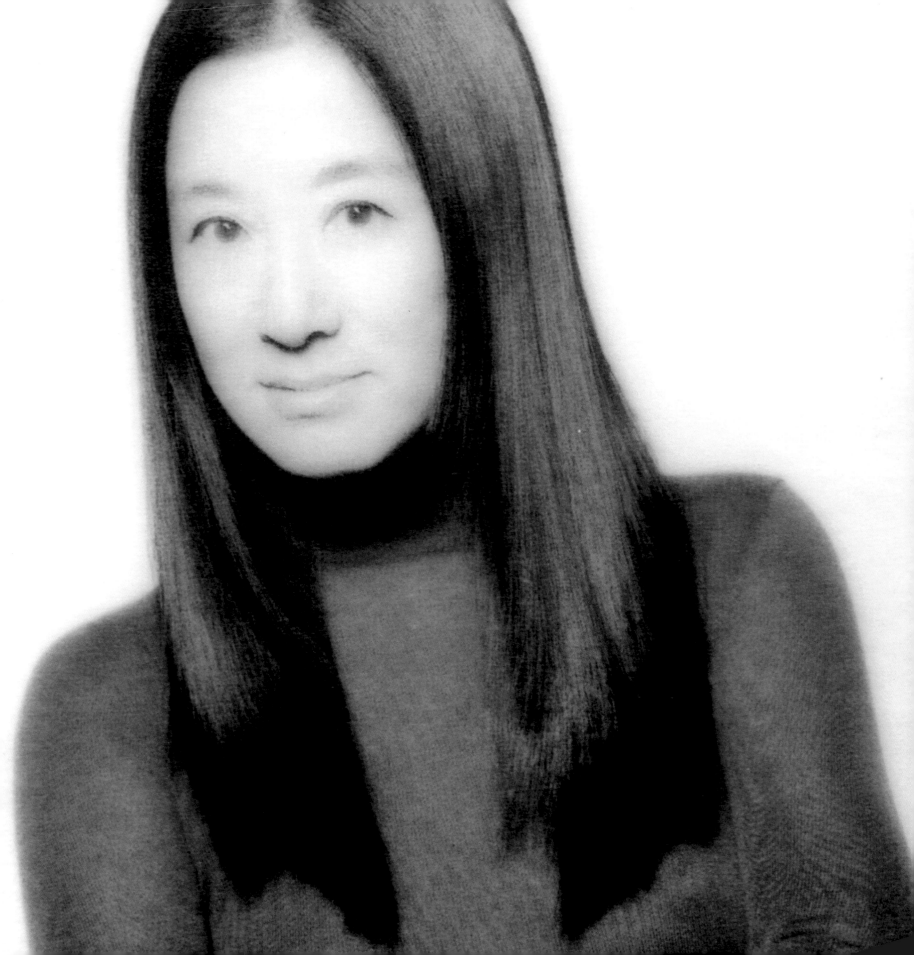

norah jones

BY KATHERINE TRADD

RECORD OF THE YEAR. Album of the Year. Song of the Year. Best New Artist. Best Female Pop Vocal Performance. This dazzling quintet of top musical honors went home with twenty-two-year-old singer-songwriter Norah Jones at the forty-fifth annual Grammy Awards, in recognition of the break-through talent on her debut album, *Come Away With Me.* Released just one year after submitting a demo tape to a friend at Blue Note Records, the song has already sold eight million copies worldwide. The New York–born, Texas-raised Jones captivated critics and consumers alike with an amazing and authentic arrival on the pop music planet.

Characterized by an innovative yet highly appealing blend of jazz, soul, pop, and country traditions, Jones attracts notice and praise from all corners. Her voice has been described as one of "engaging power." She'll tap into the reservoir of her own songwriting talent on one track, then transform a stan-dard tune with the next.

The arc of Jones's rise can be traced through indispensable bloodlines, her early love and imitation of standards by Billie Holiday and Etta James, and payment of nightly dues on the Manhattan club cir-cuit. Daughter of Indian sitarist and composer Ravi Shankar and concert promoter Sue Jones, Norah Jones blazed her way through the dual tracks of performing arts education and open-mic nights in Texas, earning the Down Beat Student Music Awards for Best Jazz Vocalist and Best Original Composition while still in high school. While majoring in jazz piano at the University of North Texas, a summer trip to Greenwich Village gave Jones an immediate opening on a world of songwriting and performance. The concentration of live music clubs and musicians, the constant interaction and collaboration, provided an instantaneous launch pad for Jones and her career.

Her New York tenure included stints at a Jewish community center followed by larger venues, such as the Knitting Factory, Joe's Pub, and the Living Room. She played with local bands, such as the Ferdi-nandos and the funk-fusion group Wax Poetic, before forming a core group of her own that caught the attention of a Blue Note Records executive. The final step came as Jones took her ideas and her polished sound into the studio during the summer of 2001, working with Arif Mardin, producer of landmark recordings by Aretha Franklin, Dusty Springfield, and Laura Nyro.

The transformation from arty jazz-house favorite to bona fide pop sensation complete, Jones is free to explore new musical boundaries. Stretching for sophistication within the comfortable confines of the house band, hers is a voice and sense of style that will not be ignored.

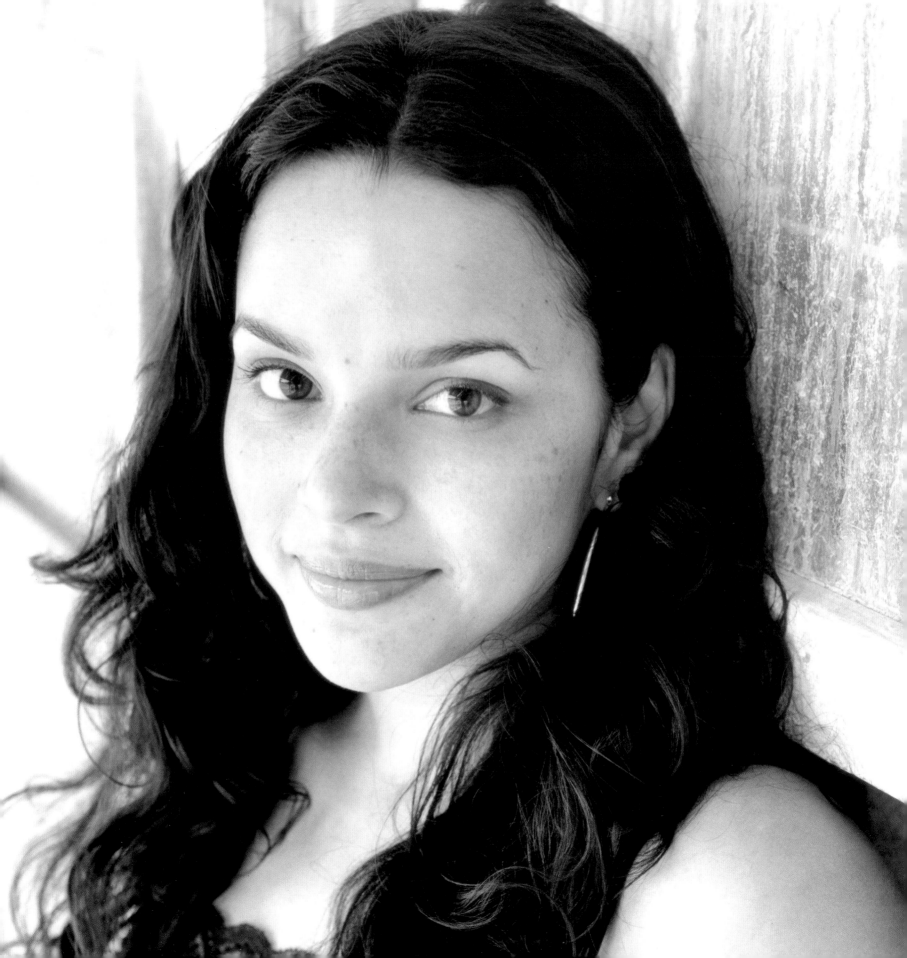

toni morrison

BY CLAUDIA DREYFUSS

THE WOMAN BREEZING INTO A PRINCETON, NEW JERSEY, restaurant in a brilliant silk caftan and with salt-and-pepper dreadlocks is Toni Morrison, the Robert F. Goheen Professor in the Council of the Humanities at Princeton University and the 1993 Nobel Prize winner for literature. Since her Grand View-on-Hudson [New York] home burned to the ground, Morrison has been living in this very Anglo-Saxon American town. "Princeton's fine for me right now," she explains as we sit down to lunch. "I'm in the middle of a novel, and I don't want to think about where I'm living."

In writing it, Morrison says she has been trying to imagine language to describe a place where "race exists but doesn't matter." Race has always mattered a lot in Morrison's fiction. In six previous novels, including *Beloved, Song of Solomon,* and *Jazz,* she has focused on the particular joys and sorrows of black American women's lives. As both a writer and an editor—Morrison was at Random House for eighteen years—she has made it her mission to get African American voices into American literature. The stories Morrison likes to tell have this deadpan/astonished quality to them. Like García Márquez, she can recount the most atrocious tale and give horror a charming veneer. One suspects that Morrison long ago figured out how to battle the cruelties of race with her wit.

She grew up Chloe Anthony Wofford in the rust belt town of Lorain, Ohio. Her father, George, was a ship welder; her mother, Ramah, a homemaker. At Howard University, where she did undergraduate work in English, Chloe Anthony became know as Toni. After earning a master's in English literature at Cornell, she married Harold Morrison, a Washington architecture student, in 1959. But the union—from all reports—was difficult. (As open as Morrison is about most subjects, she refuses to discuss her former husband.) When the marriage ended in 1964, Morrison moved to Syracuse and then to New York with her two sons, Harold Ford, three, and Slade, three months old. She supported the family as a book editor.

Evenings, after putting her children to bed, she worked on a novel about a sad black adolescent who dreams of changing the color of her eyes. *The Bluest Eye* was published in 1970, inspiring a whole generation of African American women to tell their own stories—women like Alice Walker, Gloria Naylor, and Toni Cade Bambara.

"I'm not pleased with all the events and accidents of my life," she says over coffee and a cigarette. "You know, life is pretty terrible, and some of it has hurt me a lot. I'd say I'm proud of a third of my life, comfortable with another third, and would like to redo, reconfigure, the last third."

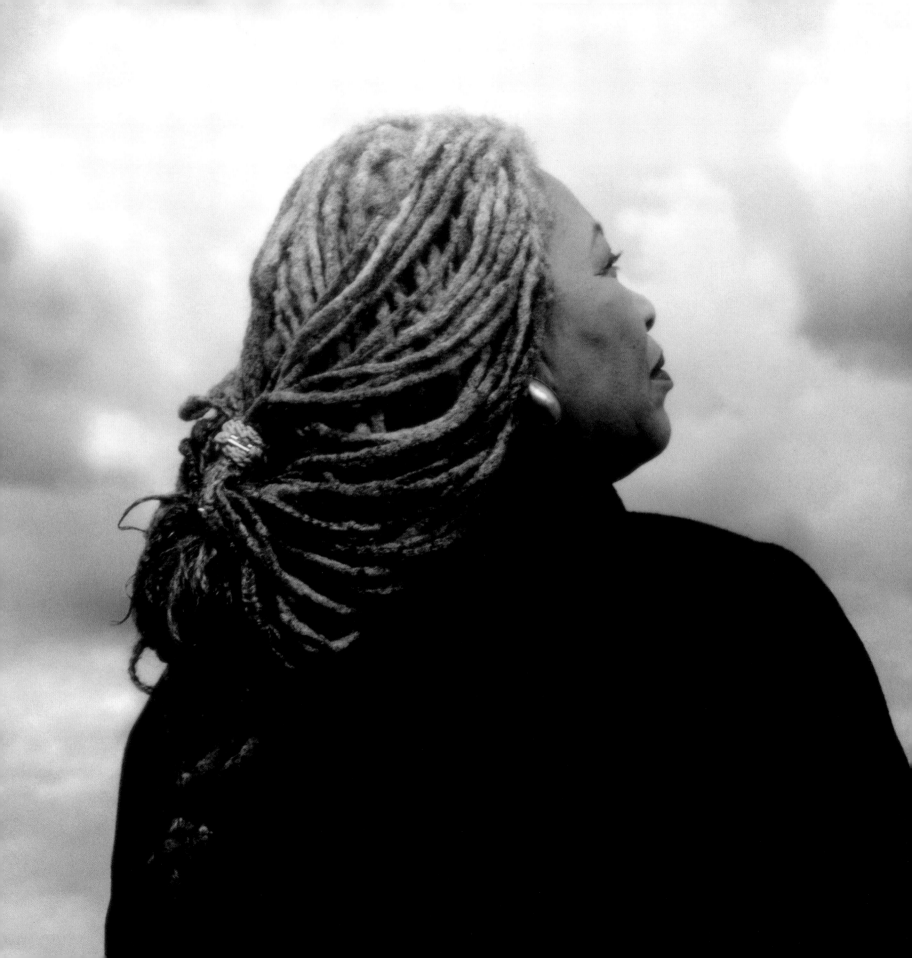

christiane amanpour

BY SHERRY RICCHIARDI

IKE WALLACE OF *60 MINUTES* praised Christiane Amanpour as "the best-known foreign correspondent in the world," one who has "covered more death and more misery than just about any other U.S. reporter in the past four years." In war reporting circles, Amanpour ranks as a four-star general. She earned her stripes covering the Persian Gulf War, then moved on to the Kurdish crisis, Somalia, Rwanda, Algeria, Haiti, and Bosnia.

Her appearance at global hot spots commands notice in high places. She once received an "Amanpour Tracking Chart" from Pentagon officials—a world map, with pins marking her movements. "A cute thing," she calls it.

Born in London in 1958—her father was an Iranian airline executive, her mother a native of Great Britain—Christiane was the oldest of four daughters. The family moved to Tehran, where she lived a "privileged, Western-style" existence. A fluke led her to broadcasting. One of her sisters applied to a journalism program in London but then changed her mind. When the director refused to give her the tuition back, Amanpour suggested she attend instead. The answer was yes. She later enrolled at the University of Rhode Island, where she began part-time work for local radio and TV stations. She graduated summa cum laude with a bachelor's degree in journalism.

Bosnia, the story that few people wanted, stands as the exclamation point of her career. At first, Bosnia was an unpopular story with opinion makers and editors. "I think there was a certain 'Who gives a damn about Bosnia' attitude among editors and policy makers back home," she says. "I believe I forced CNN to cover Bosnia on a regular basis because I was willing and eager and hungry to stay there."

How does she handle the human misery, the bloodshed? "You have to maintain a certain demeanor—not a coldness—but a certain amount of professional control," she says. "It's like being a doctor, I suppose. You know if you're going to scream every time you see blood, you're not going to be able to do your job."

"I am driven, I'm very passionate, I'm very committed, and I'm sometimes pretty loud, but I don't believe I've ever stepped over anybody or thrust anybody out of my way to get anywhere. I don't need to," she says. Is she really the hottest property in television? "Hey, I can't comment on that. What can I say, 'Yes'? Then I'm going to be arrogant. Well, I am flattered," she says. "They say I give great war. Is that sexual or what?"

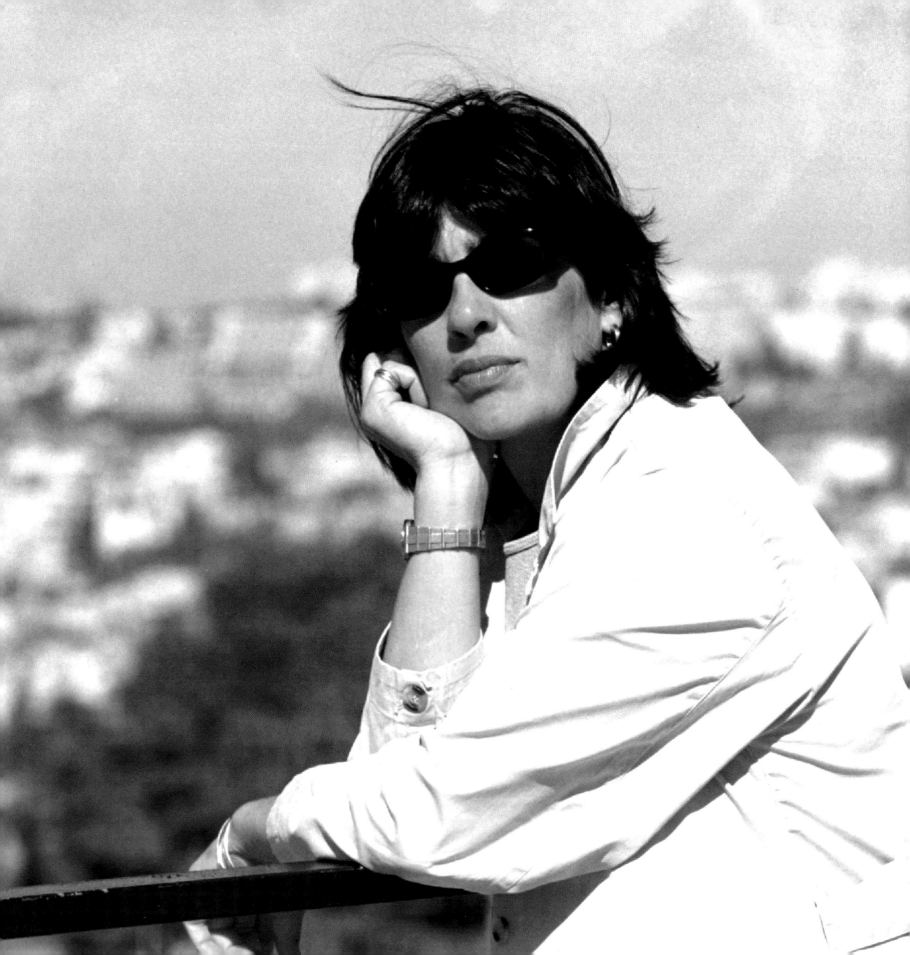

raquel welch

BY JOANNE KAUFMAN

TRYING TO DESCRIBE RAQUEL WELCH without using the phrase "sex symbol" is like trying to describe an accordion without using your hands. In fact, the actress who rocketed to fame and launched a zillion or so fantasies as the cavewoman in 1966's *One Million Years B.C.*—her dialogue, "Me Loana, You Turak," was the only thing briefer than her fur-trimmed bikini—must now add the label *sexagenarian* to her sex-symbol tag. But whether it's good genes, a good plastic surgeon, or the good offices of Ms. Welch's recently launched skin care line, *One Million Years B.C.* seems like only yesterday. "I've had a lot of longevity. People say I'm durable," said Ms. Welch.

Ms. Welch was born Jo Raquel Tejada, the daughter of a British American mother who claimed John Quincy Adams as an ancestor and a Bolivian father who determinedly made no mention whatsoever of his forebears. "When he came here from La Paz, he wanted to homogenize himself into the culture and speak only English," she explains. "He wanted us to be red, white, and blue. I never saw any of his family. When I asked him, 'What kind of a name is Raquel and what kind of a name is Tejada because people at school can't pronounce it very well' he would say 'Not now.'"

Growing up in Southern California, Ms. Welch worked through this identity crisis by making a name for herself as, among others, Miss Photogenic, Miss La Jolla, Miss Fairest of the Fair, and Miss California. "I thought it was just fine when it first happened. Yippy, skippy. What a great ticket to ride. It was like a paperback novel. But I had set out to be a serious actress."

"I have a very eclectic consciousness," she said. "I love the world of beauty and I love the world of womankind, but where I live is much more mental. And I've found that because I have a decent vocabulary people think I'm being highty-tighty."

And yet, unlike many sex symbols, Monroe, Mansfield, and Hayworth among them, Ms. Welch has survived, and in the case of the film *The Three Musketeers* and the Broadway musical *Woman of the Year*, triumphed. "I'm just gutsy, I guess," she explained.

And she's confident that finally people are willing to see her in a new way. "Maybe it's taken me this long to get to a place where most of the public isn't looking at my navel or the length of my leg and my cleavage," she says. "I do have this fierce sexuality thing, but maybe people are over it, and maybe I'm over myself enough that I can do my work. I spent so many years fulfilling other people's fantasies that I'm enjoying when I'm courageous enough to try to fulfill mine."

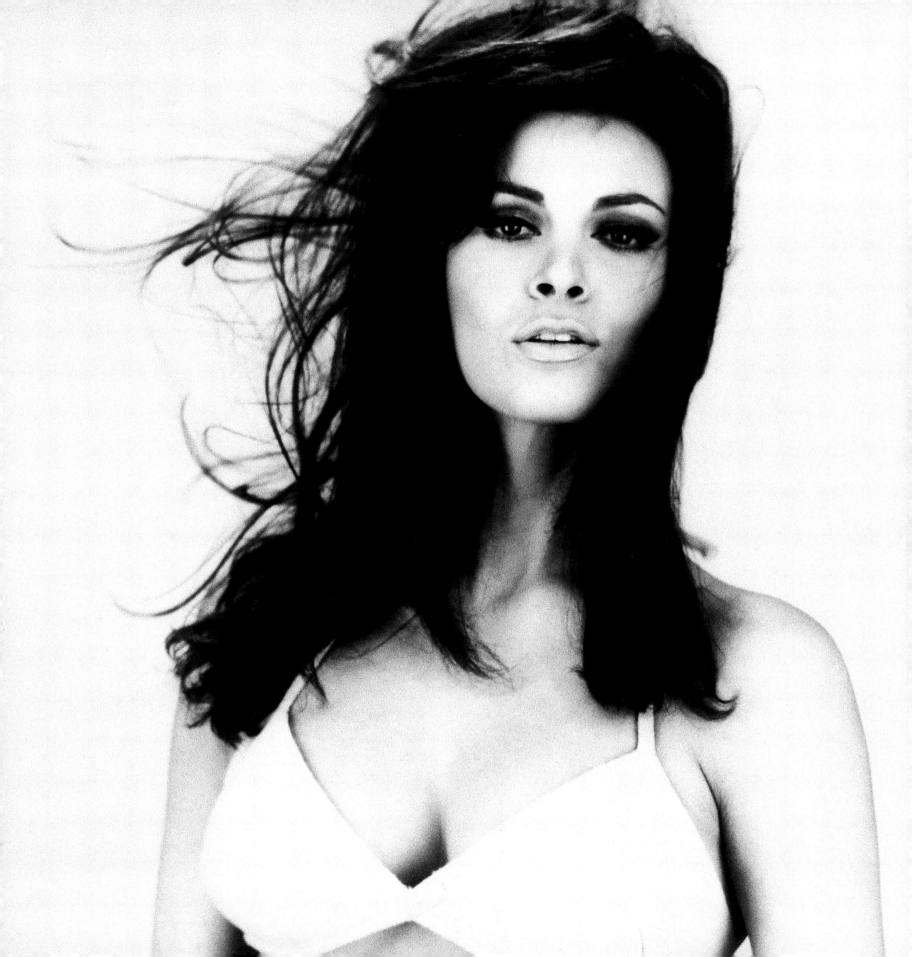

donna karan

BY STEPHANIE MANSFIELD

DONNA KARAN IS A BONA FIDE SEVENTH AVENUE CINDERELLA STORY. Since its inception in 1984, Donna Karan New York has grown to include her ready-to-wear collections and DKNY. There's also Donna Karan eyewear, hosiery, furs, shoes, perfume, and home furnishings. She says she can't help it; she's a born entrepreneur. When she has an idea, it becomes a company. Karan's professional rise has a lot to do with the current rise of "fortysomething" female executives, like herself, who want to look pulled together, but not prim. Mildred Pierce meets Murphy Brown. It also has to do with the fact that Karan is a woman. She wears the clothes. In fact, she designs for herself. "And she's the size of more women than Carolyne Roehm or Carolina Herrera is," observes fashion editor Nina Hyde.

And while the fashion press may marvel at her controlled palette or streamlined silhouettes or the neutralized leg, the designer's flotilla of fans doesn't want to get technical. To them, the clothes, which tend to flatter females of all ages and shapes, are just plain sexy—and they really work. Says customer Diane Sawyer, laughing, "You know there's a living, working, *suffering, struggling* person on the other end." Karan's clothes work for women on the go because, as the globe-trotting Sawyer says, "She knows what it's like not to have an hour in the morning to get dressed. It's grab and run."

A classic overachiever, she was born in Queens and raised on Long Island, the second of two daughters. Her father, Gabby Faske, a custom tailor who is said to have outfitted gangsters, died in a car accident when Donna was three. Her upwardly mobile mother, Helen, a Seventh Avenue showroom model who referred to herself as "the Queen," supported the family. She died in 1978.

Donna got a job in a boutique at the age of fourteen and has worked ever since. "That gave me my purpose. I loved selling. I learned what people looked good in and what they didn't." She enrolled in the Parsons School of Design, subsequently dropped out, and at age nineteen went to work for Anne Klein. She became her assistant and eventually took over the company in 1974, when Klein died. Karan took the Klein label to new heights, then left the company in 1984 to start her own. Soon christened the Queen of Seventh Avenue by the fashion press, she commuted from her home on Long Island and then eventually took an apartment in Manhattan.

She is rarely home before 10:00 or 11:00 P.M. "*Everybody* wants more of me. I don't know why, because I'm not so great to be with, you know? I'm a little flaky." And don't ask her what it feels like to be a success. She wrinkles her face and says she doesn't feel all that successful. It's never complete, she says. It's never perfect. It's never good enough.

joan didion

BY SUSAN ORLEAN

THE SIXTIES FORMED HER AS A WRITER, bracketed by the publication of her first book, the novel *Run River* in 1963, and her second novel, *Play It as It Lays,* in 1970. Joan Didion had grown up in California, in the dun-colored ranchlands of the Sacramento Valley. Her childhood was punctuated by the bombs being dropped on Hiroshima and Nagasaki, and she has been waiting for another one to drop ever since. She graduated from Berkeley "with difficulty," she declared in a 1976 essay, "not because of [an] inability to deal with ideas…but simply because I had neglected to take a course in Milton." She married John Gregory Dunne the year after *Run River* was published. She and Dunne were living in New York at the time. She finished a stint as an assistant features editor at *Vogue* and began writing taut, chilling essays for the *National Review, Saturday Evening Post,* and the *New York Times Magazine* about Vietnam, hippies, murders, and very often about California as a world both real and imagined, at once the bedrock of familiarity to her as a native and a place that was then fracturing into strange, disordered pieces.

Along with Tom Wolfe and Norman Mailer, she was inventing a new kind of journalism that slipped in and out of anthropology, politics, and autobiography. She did it even though she detested making phone calls, found writing painful, refused to deal with press agents, and considered herself a terrible interviewer. In 1964, she and Dunne moved back to California [and] began writing screenplays; the first one produced was *Panic in Needle Park* in 1971. In a way, working in Hollywood and hanging around people like Jack Nicholson and Roman Polanski seems hard to reconcile with Didion's despairing cynicism—what could be more inauthentic than Hollywood?—but it did suit her gift for storytelling and insight. "Working on movies is fun," she said. "It's totally different. It's my job, like Wallace Stevens had his insurance company job."

[In 1988,] she and Dunne moved back to New York for good. Didion misses the physicality of California life, misses the palace-size supermarkets, misses having a garden and a car and a swimming pool. Still, she seems at ease in New York, a place she wrote about loving and then leaving after "the golden rhythm" of living here was broken. She and Dunne had kept an apartment in Manhattan all the years they were living in Los Angeles, and when they were visiting New York they would have lemons and oranges FedExed to them from home.

She is planning to pick up a book she started working on back in the seventies and somehow never finished. It is the perfect subject for someone who has now settled back into living in New York—if that person is a perfect contrarian: she is writing a book about California.

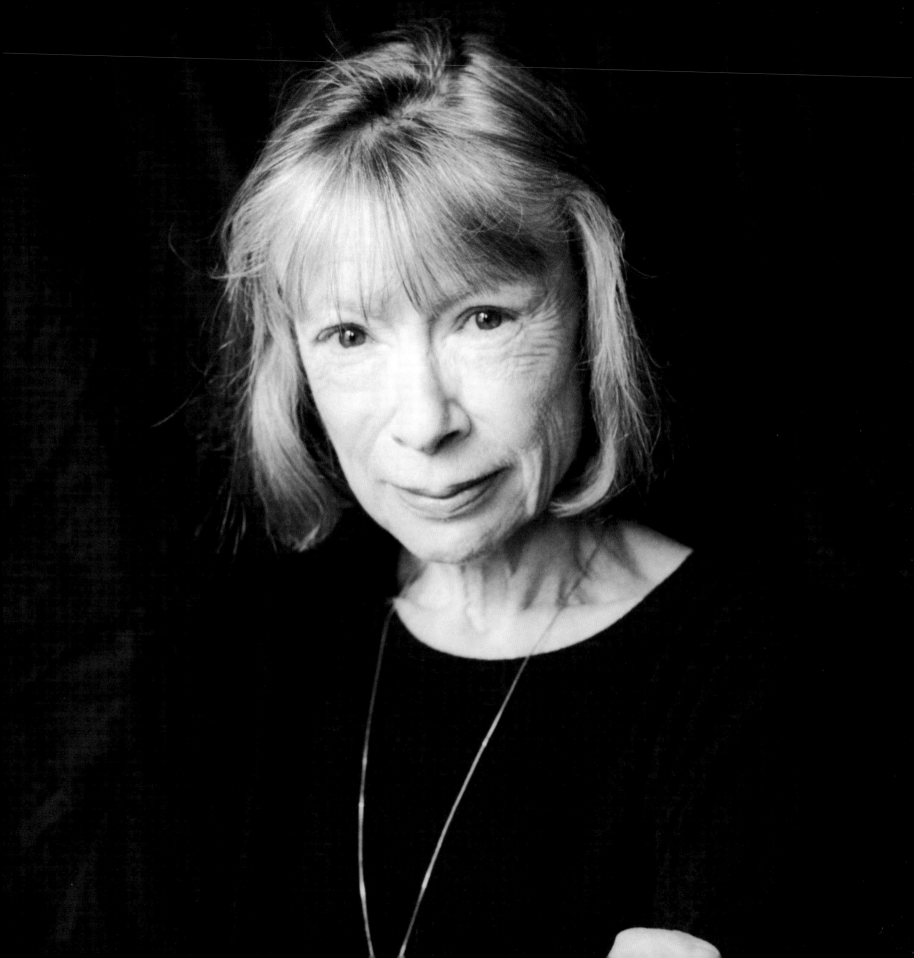

halle berry

BY AMY FISHER

I N 1954, ACTRESS DOROTHY DANDRIDGE was the first black woman nominated for the Best Actress Oscar. Almost fifty years later, Halle Berry made Hollywood history, becoming the first African American woman to win the Academy Award for Best Actress. On stage at the seventy-fifth Academy Awards, Berry thanked Dandridge. Appropriately, one of Berry's finest roles was in the television movie *Introducing Dorothy Dandridge.* Berry won the Oscar for her role as a death-row widow opposite Billy Bob Thornton in the movie *Monster's Ball.* As further proof of her searing performance, Berry earned the Screen Actors Guild's Best Actress award for her lead in the film.

Many believe Berry's struggles in life have helped to make her a better actress. Born Halle Maria Berry, August 14, 1968, in Cleveland, Ohio, to Jerome Berry, an African American hospital attendant, and Judith Berry, a psychiatric nurse, she was named after a department store (Halle Brothers). Growing up, her mixed skin color caused some kids to consider Berry too light to be African American, too dark to be white. Berry's parents fought. Her father drank, and he abused Berry's mother. When Halle was four years old, her father left for good.

Berry first gained the spotlight representing her native state, winning the 1985 Miss Teen All-American pageant, then earning first runner-up honors a year later in the Miss USA pageant. Her film acting breakthrough came when Spike Lee offered her a role as a crack addict in *Jungle Fever.* Bold in her choice of roles, Berry's film career has been turbocharged by collaboration with innovative directors and lead actors. She played opposite Warren Beatty in the 1998 *Bulworth* and had a controversial breast-baring role in *Swordfish,* a 2001 thriller with John Travolta.

Berry added a new spin to the James Bond franchise, paired with Pierce Brosnan in *Die Another Day.* She helped make the twentieth Bond installment's opening grosses the highest in history. Says Brosnan of his costar, "Halle has traveled a long road and worked hard. She has a good sense of her sensuality as a woman and she's got a real heart. Plus, she's a very, very good actress."

Diagnosed with diabetes in 1989, Berry learned to overcome the fear and control her illness. She takes medicine, eats good food, and stays in shape. Balancing family life with the brutal post-Oscar demands of the film business has changed the worldview of this breakthrough actress: "Before, when a movie was finishing, I'd call my manager and say, 'Oh my God, we've got to get a job,'" she says. "Now I have two years of work."

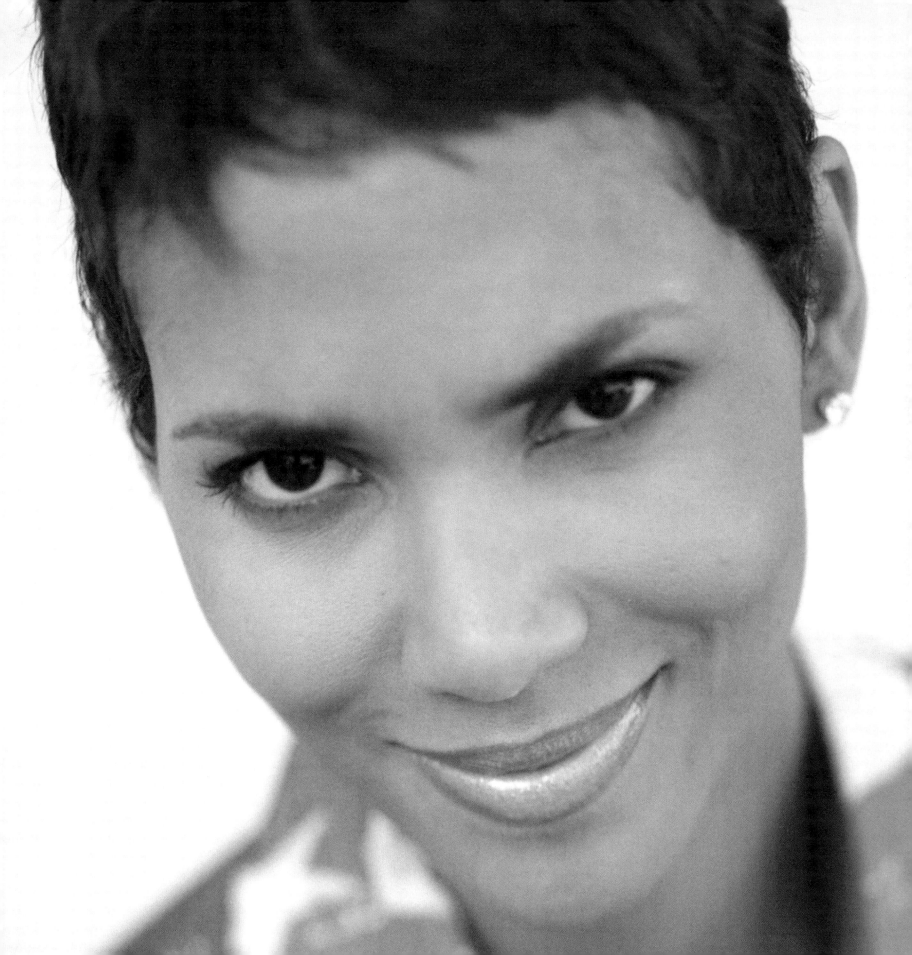

terry gross

BY ORNA FELDMAN

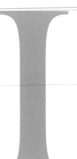

INSIDE THE WHITE, BOXLIKE BUILDING of public radio station WHYY in Philadelphia's Center City, Terry Gross questions and cajoles everyone from John Updike to Jackie Mason, Ornette Coleman to Tip O'Neill. Whether the subject is Frederic Chopin or Sid Vicious, Terry Gross is equally poised. In the last dozen years, she has engaged in witty and provocative conversations with more than eight thousand artists and experts of all genres and persuasions. She has been likened to Ted Koppel and Larry King. Yet she is one of the broadcast world's best-kept secrets.

Fresh Air, Gross's daily hourlong radio show, is broadcast on one hundred fifty public radio stations across the United States. The program went national years ago, and nearly one million people tune in every week. Gross offers them a connection to the pulse of American arts and culture available nowhere else on the airwaves, and she does it with flair.

The *Fresh Air* sound is intimate and habit-forming, like a kitchen conversation over a cup of coffee. Even the most serious interviews are often punctuated by Gross's rippling laugh, which seems to draw out the most tight-lipped of guests. Gross is a master of a diverse range of subjects, from mainstream jazz and top-of-the-news social issues to grade-B filmmakers and poster-art kitsch.

"Most interviewers have no idea how one thing relates to another," says writer Rita Mae Brown, who has been a guest every couple of years since Gross came on board as host in 1975. "They see one isolated book and sell it like a car or compare it down to nothing. It's a hatchet job or a bouquet. Terry doesn't do that. She really does know how everything fits together."

Gross's preparation for hosting *Fresh Air* began in Buffalo, as an undergraduate at the State University of New York. After graduation and a few odd jobs, she began an after-hours volunteer stint for a feminist program at radio station WBFO. It was love at first sound, Gross says. In 1975, Gross took a magazine-style format with her to WHYY, where she probed a wide variety of topics.

Gross manages to keep *Fresh Air* fresh in part because she hasn't become jaded. Robert Siegel of *All Things Considered*, relays a joke he plays on her. When he asks who the program's guest is that day, "invariably she'll say it's someone I've never heard of, like the Hungarian filmmaker Istvan Zilch, talking about his trilogy on the Turkish wars. And invariably I'll tell her we just had him on, that we just did a series on him. What amazes me is that she falls for this every other time."

Rita Mae Brown puts it differently: "People just get calluses on their souls," she says about the journalistic hazards of producing a daily show. "Terry hasn't."

queen latifah

BY DEBORAH GREGORY

S HE WEARS A SMILE OF SUCCESS we've grown to admire. The amiable hip-hop impresario Queen Latifah is reigning strong as a creative force in the pop-culture kingdom. A regal role model to homegirls everywhere, the rapper, actress, and CEO of Flavor Unit Entertainment maintains her high profile without ever compromising her artistic integrity. "I've had to make some very hard choices to stay true to my vision," she admits. "But I have found that I can be positive while still saying what's on my mind and be in projects that are inspiring." Whatever the future holds for the superachiever, no doubt it will be "Flavor-full!"

Born on March 18, 1970, Dana Owens stepped up to the mic as Queen Latifah (*Latifah* means "delicate and sensitive" in Arabic). Packing enough rhyme ammunition to send the male-dominated world of rap spinning on its Adidas, the rapper quickly garnered respect for her well-received albums and her statuesque stage presence (the Queen stands five feet nine inches tall at 190 pounds). After supporting roles in four films, including *Jungle Fever* and *Juice,* and several guest appearances on *The Fresh Prince of Bel Air* and *Hangin' with Mr. Cooper,* Latifah landed a starring role on the hit TV series *Living Single*—playing Khadijah James, an around-the-way businesswoman much like herself.

Latifah decided early on that calling the shots from the executive suite was also to her liking. Hence, she became CEO of her own company, Flavor Unit Entertainment, housed in her hometown of Jersey City, New Jersey, and brought other talent from the 'hood, including rap group Naughty by Nature, into her fold. Yet while Latifah's reign has been steady, it has also been strewn with difficulties. She grappled with the tragic death of her only and elder sibling, Lance Owens, a New Jersey police officer, who died in a motorcycle accident at the age of twenty-four. "I've learned so much about the preciousness of life from that experience," she confides.

Although it hasn't always been easy being Queen, Latifah continues to strive with her eyes on the future. As she aptly points out, "We get so caught up in our own personal struggles that we hold ourselves back. There are so many things I haven't done that I can't afford to rest on my laurels. We must think of our dreams as goals and take action to bring them to fruition, because there ain't nothin' to it but to do it!"

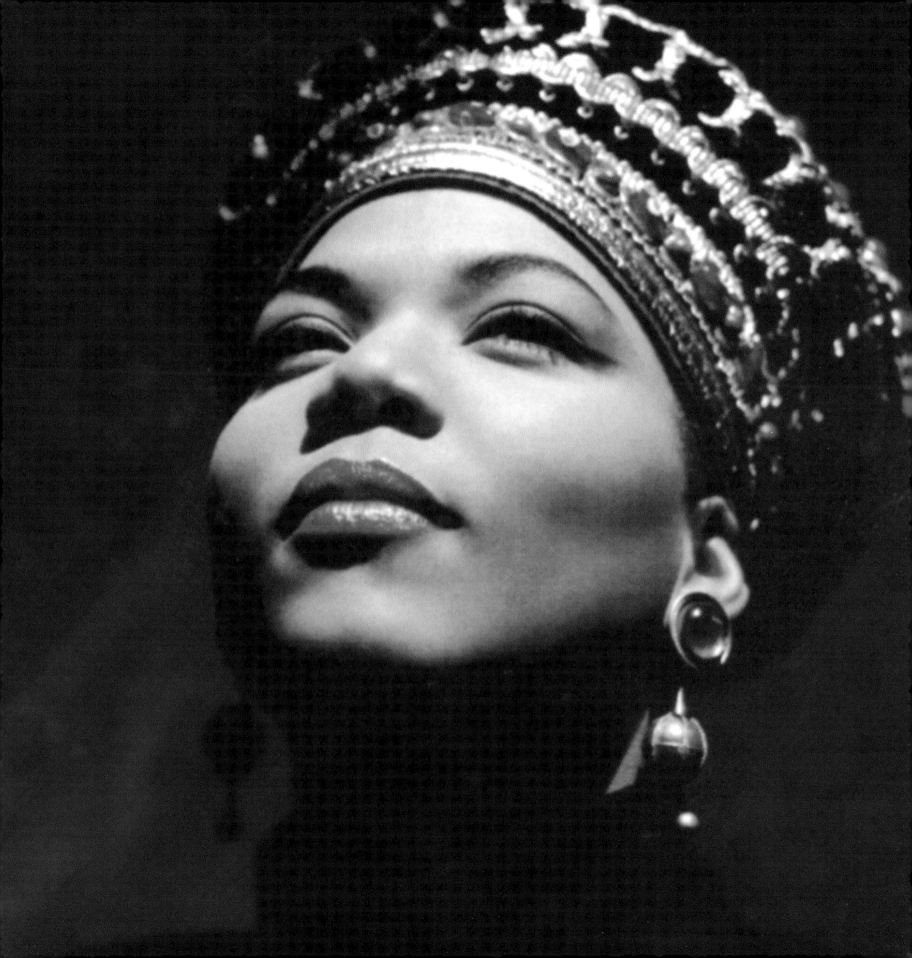

nigella lawson

BY LYNN HIRSCHBERG

"THE INTERESTING THING ABOUT FOOD," says Nigella Lawson, the British author and star of the TV show *Nigella Bites,* "is that it's both about reality and escape. After those planes bashed into the World Trade Center, I just wanted to chop something. I find that a mindless, repetitive activity loosens one up, and then, before you know it, you have made something that can seduce people. Of course, you can also make yourself fat that way."

Lawson giggles, displaying the I'm elegant-but-earthy, brainy-but-basic, sexy-peasant-with-a-pedigree persona that has made her such a sensation in England. While she is a perfectly fine cook with a solid repertory dominated by one-pot stews, roasts, pasta dishes, and lots of crumbles for dessert, Lawson, by her own admission, is no master chef. "I'm not trained," she is quick to say. "And I'm clumsy. But my feeling is if I can do it, anyone can."

On TV, she tastes constantly, licking a mashed-potatoed finger with gusto. Lawson will test a dish by tilting her head way back and dangling a noodle or string bean into her open mouth. At the end of most shows, while the orange ice cream is freezing or the pistachio soufflé is rising, she will change into a pale blue satin robe, make herself a big bowl of pasta, and climb into bed.

While the tabloids in London call Lawson "the domestic goddess" (which is lifted from *How to Be a Domestic Goddess,* her second cookbook), she did not set out to be known for her food. She studied modern languages at Oxford and planned to write a novel. In the early 1980s, she took a job as the literary editor at the *Sunday Times* [and] met her future husband, the journalist John Diamond. "My interest in cooking really began when my mother and sister died," Lawson recalls. Both succumbed to cancer, and, in 1997, Diamond found out he had throat cancer. Her husband chronicled his illness extensively before dying in 2001.

Cleverly, Diamond realized that his wife's mix of maternal and madcap would play well to the public, and he encouraged her to switch to food writing. She had always cooked for friends, most notably Salman Rushdie, for whom she once roasted lamb. "It was in the early days of the *fatwa,*" she explains, "and I opened the oven to take out the lamb, and my hair caught on fire."

"Even now, after my husband's death, and more recently after the World Trade Center attacks, I find that cooking keeps me grounded." She pauses and then continues, "Although, I am afraid to come to New York. New Yorkers are so thin. I'm afraid they'll say, 'if I had a bottom your size, I wouldn't show it off,'" Lawson laughs. "The trivial can be a tremendous comfort."

barbara walters

BY JENNET CONANT

B Y TURNS GRANDIOSE AND MATERNAL, Barbara Walters presides over a remarkable career that defies easy categorization. From the beginning, she straddled news and entertainment, ranging from her famous interviews with foreign leaders, such as Muammar Qaddafi, King Hussein, and Fidel Castro (who once approached a pack of journalists and asked "Dónde está Barbara?"), to her infamous "What kind of tree are you?" interview with Katharine Hepburn. Year after year, no one in the business scores as many sought-after exclusives; a list of coups includes Colin Powell, rival O. J. Simpson attorneys Robert Shapiro and Christopher Darden, Christopher Reeve, and Michael J. Fox. Walters has achieved a level of prominence, both professionally and socially, that eclipses that of most of the people she interviews. Her name is as apt to turn up in the society pages as it is in the television section, and she is a regular on best-dressed lists. And, like so many of the celebrities she interviews, Walters is a tabloid staple, often meriting column inches in the *Globe*, the *Star*, and the *National Enquirer* (she reads them all).

Although Walters specializes in celebrity sob stories, she has little patience for her own hard-luck tale. But if she is as driven as her colleagues say she is, it may date back to a boom-and-bust show-business childhood and a father who hit it big and then lost it all. By her account, Lou Walters was always better at show than business, and in the early part of her childhood the family had little money. "I didn't have what I would call a happy-go-lucky childhood," she says tersely, dismissing its influence on her later career. "I was a very serious little girl."

With mornings of *The View,* and her specials—including the Oscar show, *The Ten Most Fascinating People,* and *Six to Watch*—Walters has never been busier. Ted Koppel thinks Walters is as tough as she ever was. "She'd still chew off your leg for an interview," he says, adding that she would have made a good Mafia boss in another life. "Most of us lose a competitive step as we get past forty. I'm pretty competitive, I know Peter is, and Sam and Diane are. But Barbara is in a class by herself."

Nevertheless, signs abound that the matriarch of ABC is mellowing. At the party celebrating a wedding, Walters stood up and said the proof of how much she cared about them was that she could bring herself to say Sherrie Rollins's name publicly—an unheard-of reference to her speech impediment. It is a subject no one at ABC would have dared mention. Except for Walters, who, for her many hairdos, breathless questions, and blubbery guests, is still the gamest broad on the air.

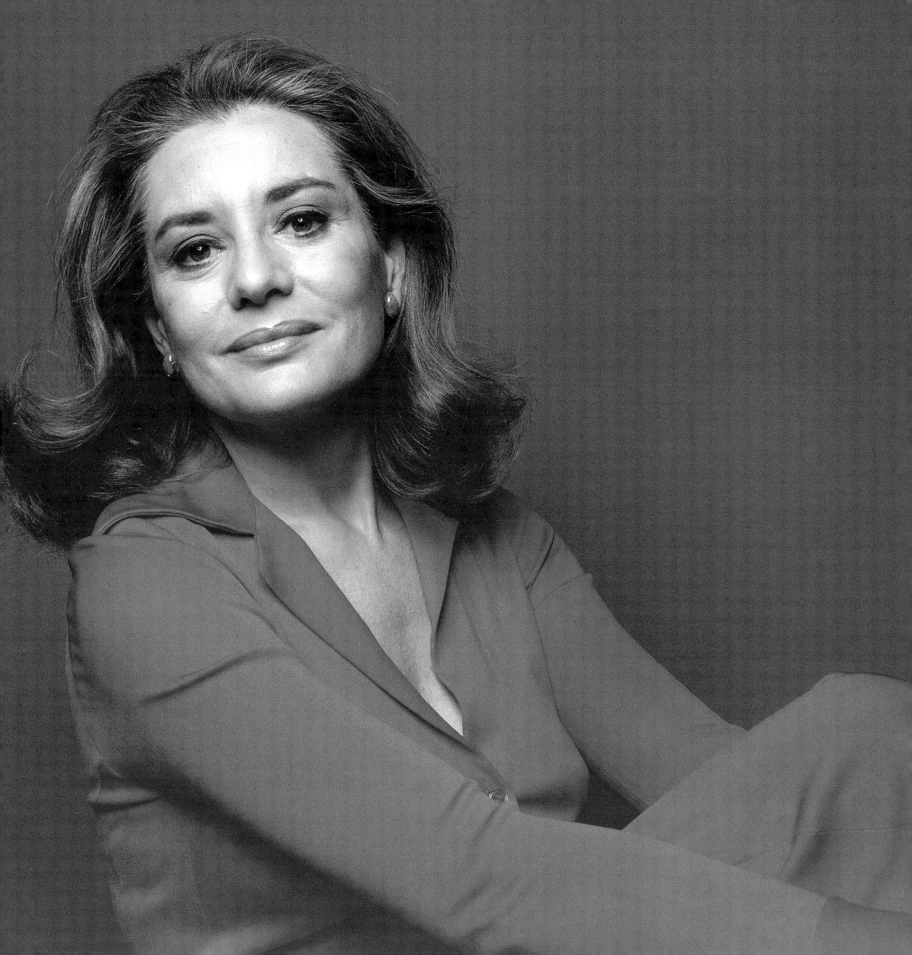

nicole kidman

BY DOROTHY SUMMERS

ISPLAYING A REMARKABLE RANGE of acting talent and personal tenacity, Nicole Kidman has established her reputation and rapport with a worldwide audience on her own terms. Turning a breakup with husband Tom Cruise into a breakthrough, Kidman has leveraged authenticity and focus on her craft into box office stature. As the momentum of a twenty-year professional film career advances Kidman's success, you get the feeling that the willowy and wise Aussie actress is just now hitting her stride. And the professional awards and critical acclaim are merely playing catch-up.

In 2003, she won both an Academy Award and a Golden Globe for her performance in *The Hours*, starring as the author Virginia Woolf alongside Meryl Streep, Julianne Moore, and Ed Harris. She's currently starring opposite Anthony Hopkins in the film adaptation of the bestselling book *The Human Stain*, and upcoming projects include Jonathan Glazer's *Birth*, Frank Oz's remake of the 1975 thriller *The Stepford Wives*, and the *Dogville* trilogy from Danish filmmaker Lars von Trier.

Born in Hawaii in 1967 to Australian parents, Kidman was raised in the Sydney suburbs. Teased relentlessly because of her height, Kidman took refuge in the theatre and landed her first professional role at the age of fourteen, when she starred in *Bush Christmas*, a TV movie about a group of kids who band together with an Aborigine to find their stolen horse. In 1985, when she was only seventeen, members of the Australian Film Institute voted Kidman Actress of the Year for her work in the TV miniseries *Vietnam*. By the time she made her first American film, 1989's *Dead Calm*, Kidman was already a popular star in Australia.

Despite high-profile billing opposite George Clooney, Dustin Hoffman, and Cruise over the course of the last decade, Kidman's mastery of complex roles can be found in her chilling portrayal of the murderous TV reporter Suzanne Maretto in the Gus Van Sant–directed black comedy, *To Die For*, or her graceful performance as a young mother alone with her children in a spooky house in 2001's sleeper hit *The Others*. Headlining as a cabaret singer in the lively musical *Moulin Rouge* brought the versatile Kidman a Golden Globe for Best Actress in a Musical or Comedy in addition to earning her an Oscar nomination for Best Actress.

In the end, Kidman's distinctive features helped shape the person she became. "There's something you hate about looking different, and then there's something that it gives you," she says in a recent *People* interview. "It makes you develop your personality. Because you don't conform, you have to find different ways of expressing yourself."

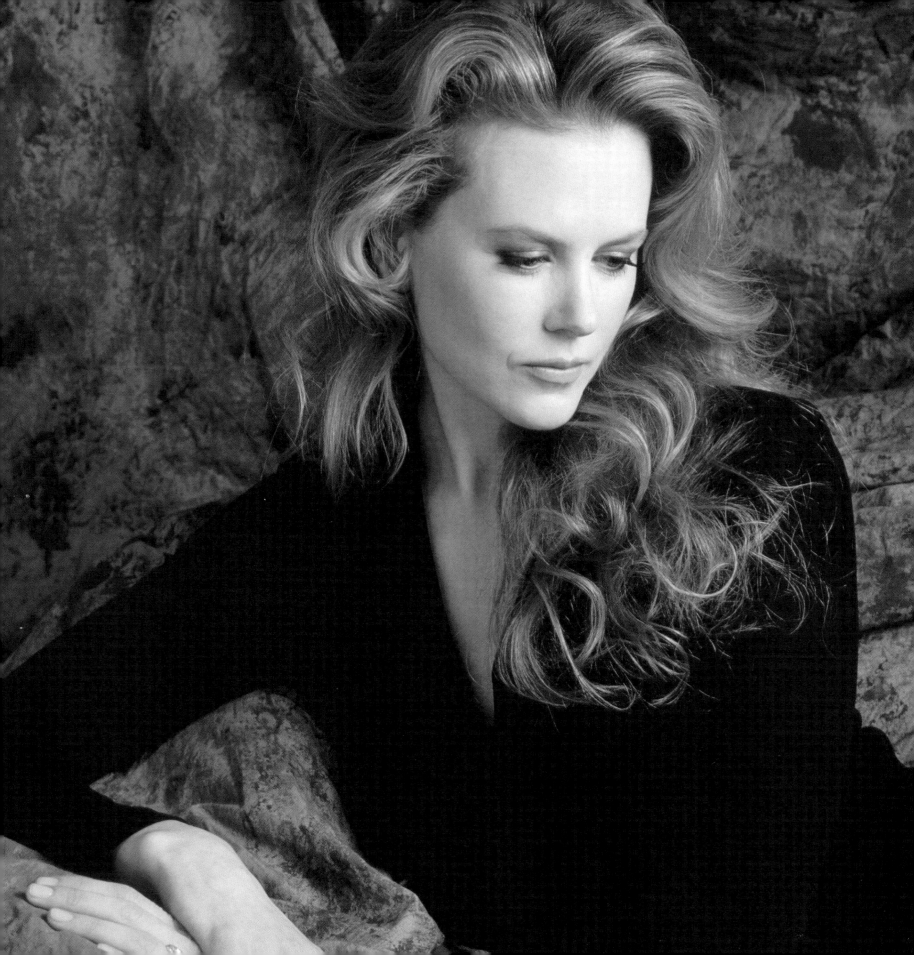

zaha hadid

BY KELLY BEAMON

I
F IT CAN BE SAID THAT BUILDINGS are not so much made as born, then architect Zaha Hadid has been in labor an awfully long time. But it's finally time to break out the cigars. The most admired female architect in the world is bringing forth a veritable brood of buildings. The Contemporary Arts Center in Cincinnati, Ohio, the first major American art institution to be designed by a woman, has started construction. A garden exhibition center in Weil am Rhein in Germany, her second building for furniture manufacturer Vitra, recently opened. And Hadid was named the winner of a worldwide competition for a contemporary-art center in Rome, beating out such highly regarded designers as Jean Nouvel and Rem Koolhaas.

If there is an antithesis to an overnight success, then Hadid is it. She arrived on the architecture scene in 1983, when she won a prestigious international competition to design a sports club on the Peak, the mountain in Hong Kong. The financing for that ambitious building fell through, but her drawings and the design—a dramatic cantilever jutting out of the mountain like a futuristic rock ledge—were wildly praised by the architectural fraternity.

It was a situation that would become familiar to her. When she won the international competition for the opera house in Cardiff, Wales, controversy began. An outspoken Arabic woman proposing an intellectually demanding, uncompromising design in a Britain in which the future king publicly bemoaned the lack of pretty, traditional buildings was destined for a tough time. Slowly the promised funds for that project evanesced. But the seductive stylized drawings and paintings of her work, plus the fact that she was a female architect of consistent vision, backbone, and—as a made-for-media bonus—booming voice, frank views, and flamboyant wardrobe, put her in the awkward position of having fame and headlines aplenty but buildings few. It's almost ironic that Hadid's design for Cincinnati should have the best chance of all her work of being built. From this staircase visitors can get fleeting glimpses of the art from unusual perspectives, a pattern that's repeated throughout the gallery, which is punctuated with jagged openings and unexpected views.

"Instead of seeing the sanctified object fixed in its niche," Hadid says about viewing the art, she wanted to "create a richer, more perplexing experience, taking your body through a journey of compression, release, reflection, disorientation, epiphany."

Despite the tortuous turns in her career, Hadid says she's not bitter. And she doesn't believe in glass ceilings. Unless, of course, she's thinking of designing one.

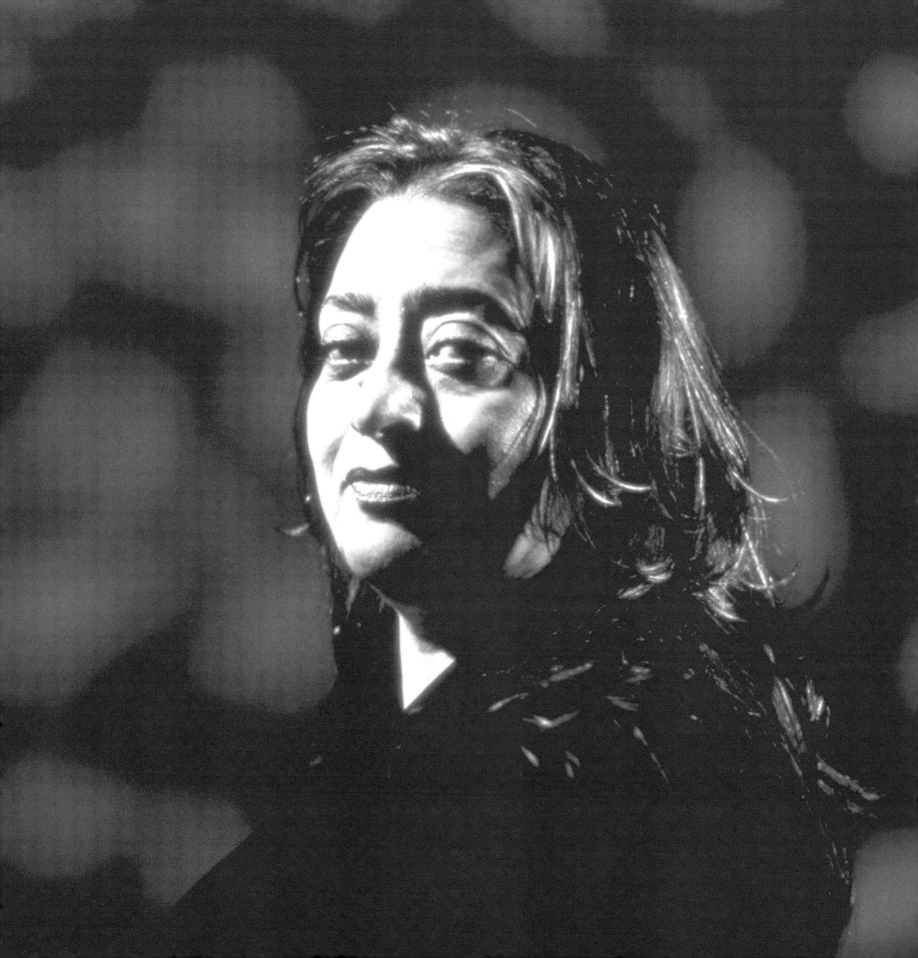

candice bergen

BY JUDITH NEWMAN

THE FIRST THING YOU NOTICE about Candice Bergen is her astonishing beauty. Bergen has a complex face that invites study. There is, perhaps, a trace of melancholy, the residual effect of the loss of her husband, Louis Malle, in 1995. But there is sly humor, too; at Bergen's most composed and serious, a bemused smile is forever playing about her lips. "What people don't know about Candice is that she's not just a little bit funny—she's hilarious," says her longtime friend Diane Sawyer. "She is also an incredible mimic. She can do a great impersonation of me and Mike Wallace, for instance."

She wasn't merely impersonating journalists for long. For ten years, as Murphy Brown, she got to play one on TV.

The child of ventriloquist Edgar Bergen and model Frances Westerman, Bergen wrote perceptively about life in the limelight, as the privileged "sister" of wooden dummy Charlie McCarthy. The sunny, picture-perfect exterior, so suitable for Dad's photo ops, belied a solitary and introspective little girl who both counted on and was terrified by her own beauty. Flunking out of college was something of a wake-up call, though she didn't exactly have to work at Denny's; modeling and acting jobs followed. She won acclaim for meaty roles like the lesbian Lakey in *The Group*, the dream girl in *Carnal Knowledge*, and the aspiring singer who couldn't carry a tune in *Starting Over* (for which she won an Oscar nomination for Best Supporting Actress).

"I wasn't very gifted at relationships," Bergen admits. Until, that is, she met French director Louis Malle. Bergen has not spoken openly about Malle's death. Friends say his was a brutal and incapacitating form of lymphoma. "I think you never get over a tragedy like your husband's death. But she's also a constructive, positive person who would not let his death distort her life," says her close friend, photographer Mary Ellen Mark.

Bergen's career decisions have revolved around being available to her child. "Most of the kids I grew up with, their parents were in show business—they were away a lot," Bergen explains. "I remember being in tears at the hospital after Chloe was born, at the thought that someday she would have to leave home."

Staying grounded has been Bergen's secret to living a life that's real—a life where you know who your friends are. "When I think of Candice, I think of tenderness," says Diane Sawyer. "She's the call you get when you need consoling, and nobody in the galaxy noticed but her."

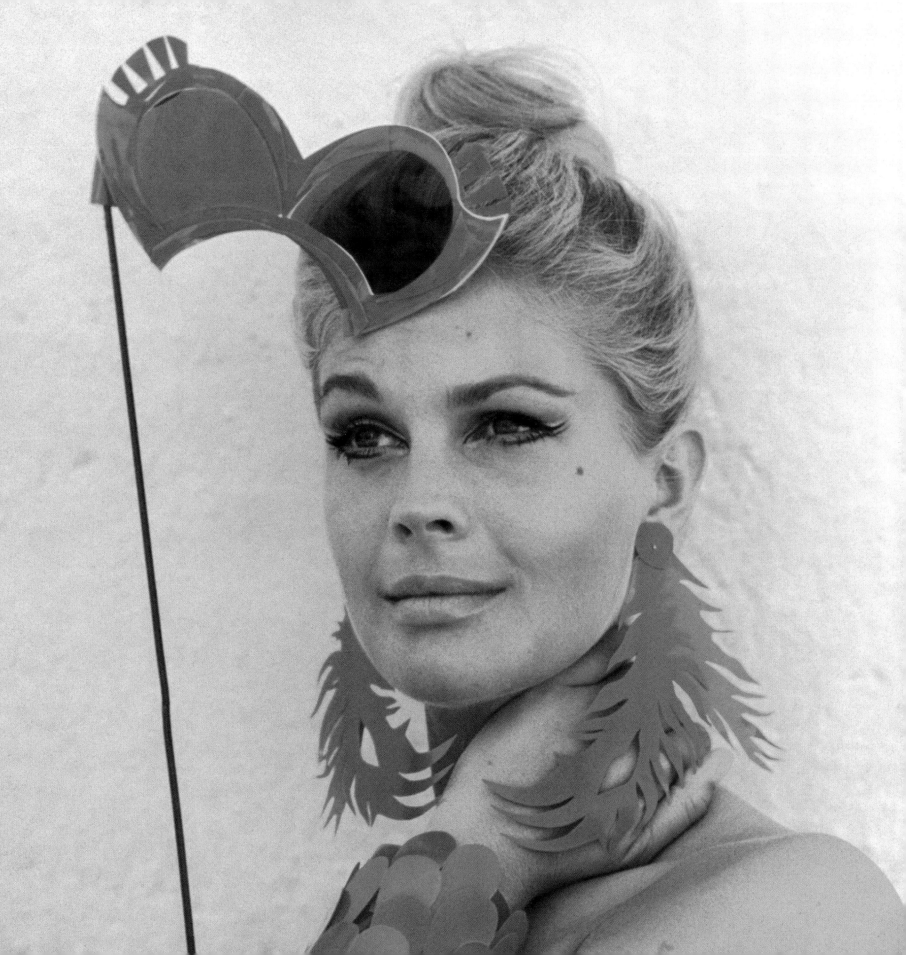

cathy freeman

BY SARAH GOLDMAN

FTER WINNING THE WOMEN'S 400-METER RACE in record time at the 1994 Commonwealth Games in Victoria, British Columbia, Canada, Australian sprinter Cathy Freeman circled the running track hoisting both the Australian and Aboriginal flags. For the twenty-one-year-old Freeman, it was the breakthrough act of a patriotic Australian and a proud Aborigine.

As international personality and role model, symbol of Australia and all its people, Freeman will always be identified with the original inhabitants of Australia. Aborigines make up just over two percent of the country's nineteen million people and have historically been victims of discrimination. In 1988, when Freeman arrived at the girl's school Fairholme College in Toowoomba she was one of only three black students out of six hundred. Working her first job behind the counter of the post office in Melbourne, people in the queue refused to be served by her. "Being Aboriginal means everything to me. I feel for my people all the time. A lot of my friends have the talent but lack the opportunity."

On a July night in Atlanta, Freeman earned her first Olympic medal at the 1996 Olympic Games. She won the silver medal in the Women's 400-meter, finishing only .4 seconds behind rival Maria-Jose Perec of France in what some have termed the greatest women's 400-meter race of the modern era.

She was born Catherine Astrid Salome Freeman in February 1973 to Norman and Cecilia Freeman as one of five children, [and in 2000,] the time had come for the world-renowned athlete of destiny to come home to Australia in order to showcase her talent and heritage. On September 15, 2000, the Olympic torch relay ended its journey in Sydney as Cathy Freeman lit the Olympic cauldron with four billion people worldwide watching.

A week later, the entire nation stopped to watch Freeman fulfill those expectations, winning the 400 meters in 49.11 before a crowd of 110,000 inside Stadium Australia and a worldwide television audience. Freeman ran the race in her usual style, conservatively for the first 300 meters, with sheer power and strength in the final 100 meters. She sat down on the track, overcome with joy, relief, and happiness, then proceeded with her victory lap.

Freeman went on hiatus following the Sydney Olympics, moving to Oregon to be with her husband, Nike executive Sandy Bodecker, and working as a volunteer for a homeless advocacy. Lacing up her spikes after a fifteen-month break, Freeman returned to a full training regimen in 2002, eyeing the 2004 Olympic Games in Athens, Greece.

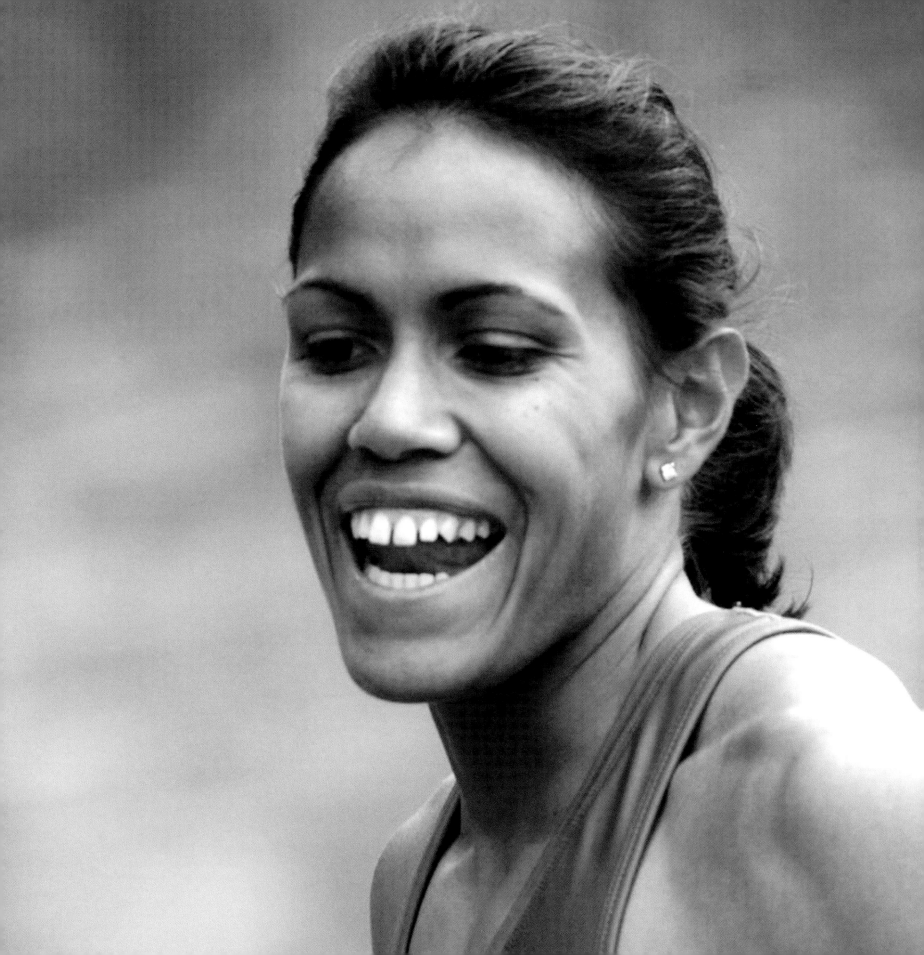

alice waters

BY MARIAN BURROS

THROUGH HER RESTAURANT IN BERKELEY and as the author or coauthor of six cookbooks, Alice Waters has single-handedly changed the American palate, inspiring a devotion to seasonal cooking and emphasizing the importance of local, organic ingredients, both of which have helped nourish farmers' markets all over the country.

Alice Louise Waters, one of four daughters born in Chatham, New Jersey, is no longer just a restaurateur. Chez Panisse, which she opened just to entertain her friends, has become a shrine to the new American cooking and a mecca of the culinary world.

Now Ms. Waters is on a mission: she believes that if all Americans sat down with their families to eat dinner every night, if all Americans had access to fresh, organic food, if all Americans worried as much about the environment as they do about their potato chips, the world would be a better place. At the University of California at Berkeley in the mid-1960s, Ms. Waters was part of the free-speech movement that led to greater self-determination on college campuses and to a wave of uprisings that included the Vietnam War protests. But unlike most other 1960s radicals, Ms. Waters has never lost her idealism. "We really felt we could change the world," she said. "I still do." She wants to do it through food.

After graduating from Berkeley in 1967, Ms. Waters taught at a Montessori school and cooked for her friends every night. When she realized that she preferred cooking to teaching, she and her friend Lindsey Shere decided to open a Provence-style restaurant.

"We had this little fantasy," Ms. Waters said. "'Oh, let's have a little café,' we said. I wasn't worried about paying for it. I just knew if I did the right thing, people would come. We opened the restaurant with ten thousand dollars. My father mortgaged his house. We had fifty employees and paid them each five dollars an hour." It was eight years before the restaurant showed a profit. It stayed afloat through loans from friends. But Ms. Waters never gave up demanding the perfect little lettuce, the most exquisite goat cheese. And the longer she demanded, the easier it was to find them. Pretty soon chefs all over the country were demanding the same.

"The act of eating is very political," she said. "You buy from the right people, you support the right network of farmers and suppliers who care about the land and what they put in the food. If we don't preserve the natural resources, you aren't going to have a sustainable society. This is not something for Chez Panisse and the elite of San Francisco. It's for everyone."

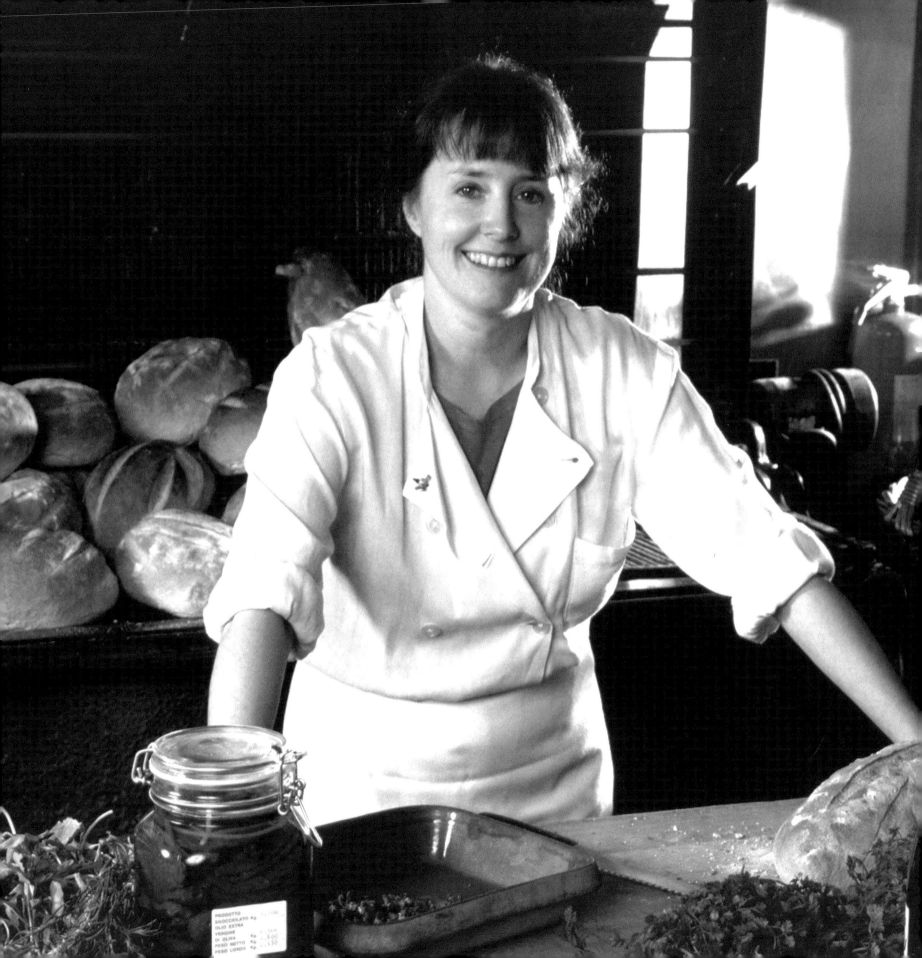

twyla tharp

BY HOLLY BRUBACH

OVER THE YEARS, WE'VE WITNESSED TWYLA THARP'S transformation from a 1960s modern-dance experimentalist into one of the leading choreographers in the world today, working for her own company, ballet companies, the movies, and Broadway, as she has tackled the various problems she's set for herself—how to use different kinds of music, the proscenium stage, narrative, the camera. She has choreographed for Mikhail Baryshnikov, the ballet virtuoso; John Curry, the ice skater; and Lynn Swann, the Pittsburgh Steeler.

Her work is by turns nonchalant and manic, reverent and smart-alecky, elegant and cutesy, tender and brutal, pugnacious and ingratiating, magnanimous and mean-spirited—never boring but often maddeningly double-edged. There is no question that her best works—*Baker's Dozen, Nine Sinatra Songs, The Fugue, Deuce Coupe,* and *The Golden Section* from *The Catherine Wheel* among them—are masterpieces. The course of Tharp's self-education is so clearly laid out in her dances that even when we don't like a particular piece, we can respect her reasons for making it. Seen in the context of her quest to be better than her best efforts, even her failures are ennobled.

Along the way, Tharp has managed to attract the glamorous and persuade them of her calling. The invitation to the gala for her company's opening night this season began "Robert Redford and the Board of Directors request the pleasure of your company" and featured the roster of her "Creative Council," a group apart from the board and from the fund-raising benefit committee, including Richard Avedon, Leonard Bernstein, Leo Castelli, Oscar de la Renta, Robert De Niro, Annie Leibovitz, and others.

If anyone can succeed in teaching herself how to choreograph classical ballets, it is probably Tharp. Her emotional drive, her intelligence, and her sheer talent will see her through, if only she can harness her ambitions and transform them, so that they don't subvert her work. Choreographers like Peter Martins and Helgi Tomasson, who, as dancers for the New York City Ballet, inherited the right to inhabit the classical tradition, go about their work with a sense of entitlement. Tharp is determined to earn that right for herself, and she relishes the effort. If she were anyone else, she might reasonably devote the rest of her career to doing the things she has already proved that she does well—doing more of them and doing them even better. But no, Tharp wants it all, and though deep down we sense that even that won't be enough, anything less would be too easy.

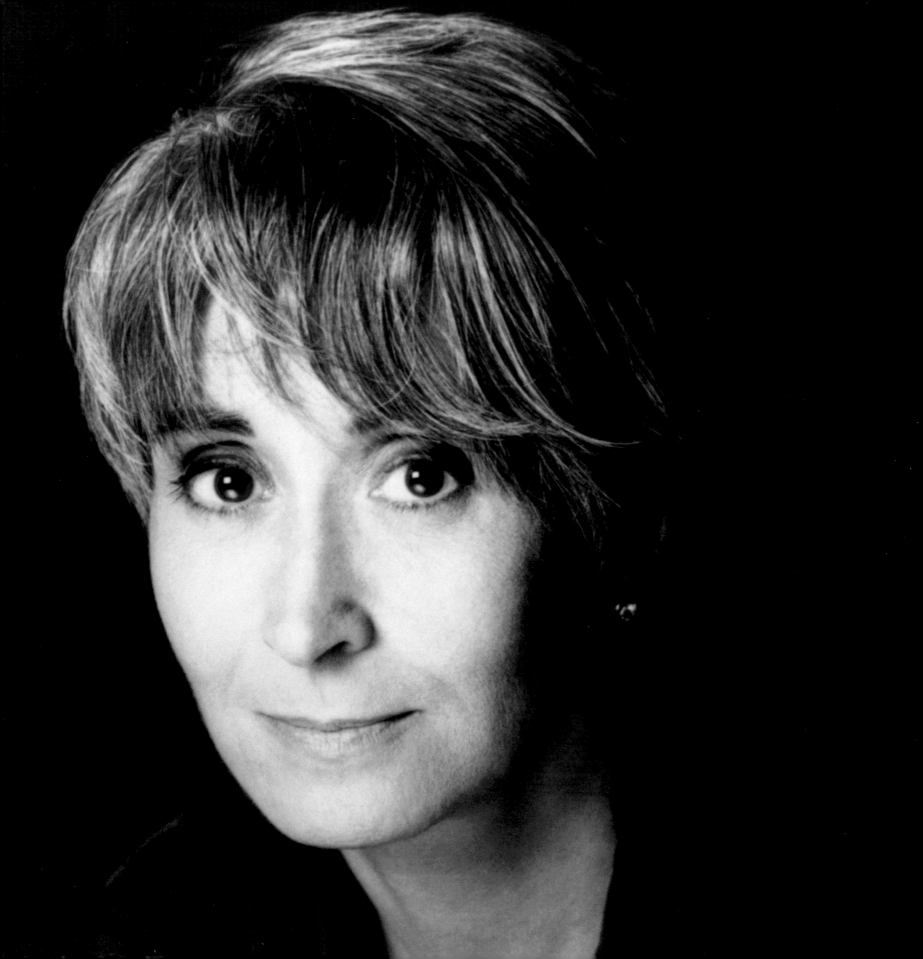

eleanor holmes norton

BY CORETTA SCOTT KING

ELEANOR HOLMES NORTON HAS ALWAYS BEEN enmeshed in America's contradictions. She was born a black child in the nation's capital when it was a segregated Southern bastion. She grew up in the city that symbolized freedom and democracy when our government denied its citizens self-government at home and representation in Congress. And she became a young woman when we all lived in a man's world.

She has challenged every barrier designed to contain her and others like her. The capital and the rest of the country are no longer segregated by law because her generation of activists—adults and students—would no longer have it. The man's world is opening to women because Eleanor and her generation of feminists insisted. The District of Colombia has a home-rule government, and the woman the city has chosen to bring complete self-government and full congressional voting representation is Congresswoman Eleanor Holmes Norton, the city's native daughter.

Eleanor was one of the generation of students who went South, inspired by Martin Luther King Jr. and his philosophy of direct action and nonviolent resistance. I met Eleanor when she was a young woman, and I learned that she had gone to Antioch College, where both my sister and I had attended. The friendship between Eleanor and me, however, has been based on more than an old school tie. For both of us, our nonconformist college suited our mutual understanding that there was work to be done in a world that needed changing.

Eleanor, fighter for great causes and mediator among diverse groups, rose from the civil rights movement to enforce the laws she struggled in the movement to achieve. She went from being a foot soldier in the Student Nonviolent Coordinating Committee to being the first woman to chair the U.S. Equal Employment Opportunity Commission, and from the segregated schools of the nation's capital to the House of Representatives. Eleanor's life tracks and embraces the great movements for justice of our time. Racial justice has been Eleanor's anchor, but she has used her experience as a black woman in America to set sail to many other shores of injustice as well.

As Eleanor says, and as Martin Luther King Jr. believed, "Human rights is all or nothing." She has lived her credo.

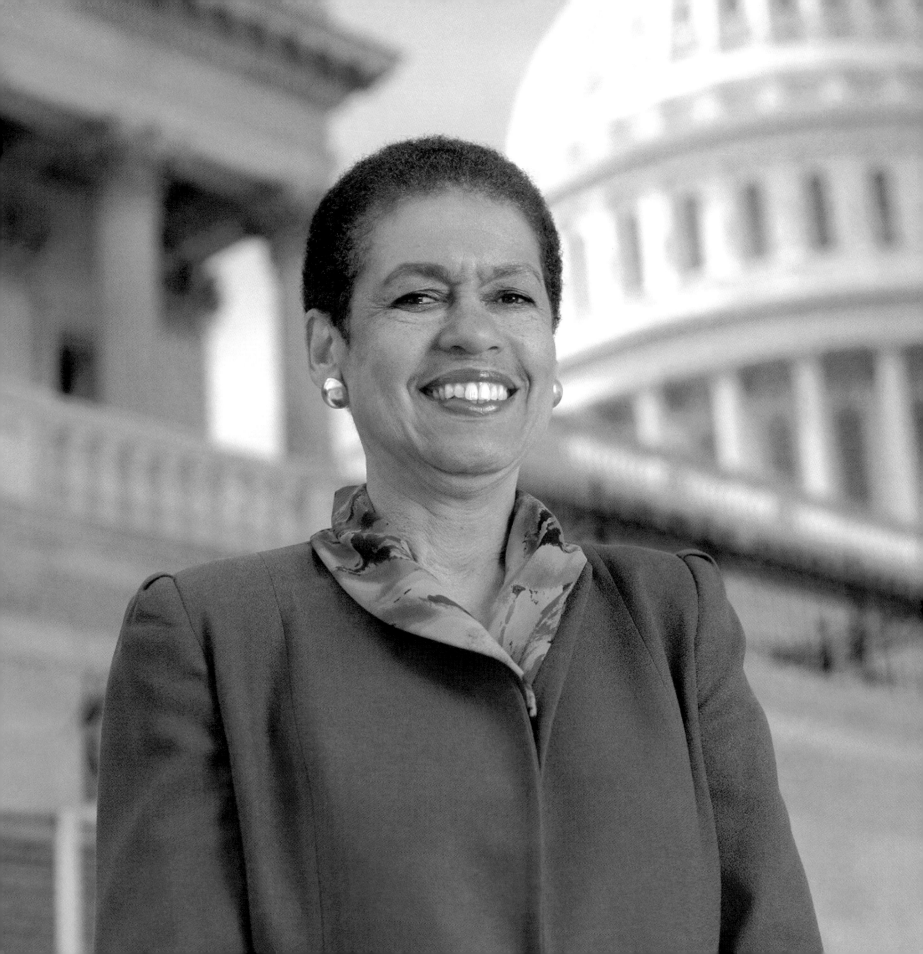

chrissie hynde

BY EVELYN MCDONNELL

CHRISSIE HYNDE IS ONE OF THE LAST GREAT ROCK STARS. She's a writer with a consistently wise-ass romantic vision, the singer with the tough, vulnerable tremble, the original American punk in London. Hynde has long been one of popular music's more outspoken personalities. In the Pretenders' early days, stories of her wild-child behavior abounded: how she once kicked out the windows of a police car; how she dedicated her cover of the Kinks' "Stop Your Sobbing" to Kinks' singer Ray Davies, the father of her first child, after she had left him for Simple Minds singer Jim Kerr, the father of her second. Later, the animal-rights activist made headlines for implying that people should bomb McDonald's for encouraging meat consumption. A few years ago, she was arrested at a Gap store during a protest of the company's use of leather. Still, at heart, Hynde remains a "divorcée ex–cocktail waitress" from Akron who chased her dream of being a rhythm guitarist a little further than most.

In 1974, Hynde moved to London with Iggy Pop's name literally etched on her sunglasses. She began writing for the music press but realized she'd rather make music. She almost formed a band with the Clash's Mick Jones but instead enlisted three guys to be the Pretenders. The Pretenders' '80 debut channeled punk's pissed spirit into songs written by someone with a love of Top 40 radio. Hynde was the only one of the class of '77 to have mainstream American success, in part because on songs like "Middle of the Road" she wrote about mainstream America.

But she also faced great obstacles. In '82, she fired founding member Pete Farndon because he was addicted to heroin. Two days later, guitarist James Honeyman-Scott died of an overdose. Ten months later, Farndon OD'd as well. The Pretenders have had up-and-down success. Their excellent 1994 album, *Last of the Independents,* tapped into the resurgence of interest in alternative-minded rock bands, especially those fronted by women.

But these days, a new generation of pop stars seems to be following in her footsteps, not Madonna's. Hynde says she likes Michelle Branch, with whom she performed at the Lifetime concert.

Last year the Pretenders opened for the Rolling Stones on part of their American tour. Hynde says seeing those graying icons every night was "fantastic." Did seeing them give her hope and inspiration for continuing her own career? Says Hynde, "I just keep doing it if I feel like it."

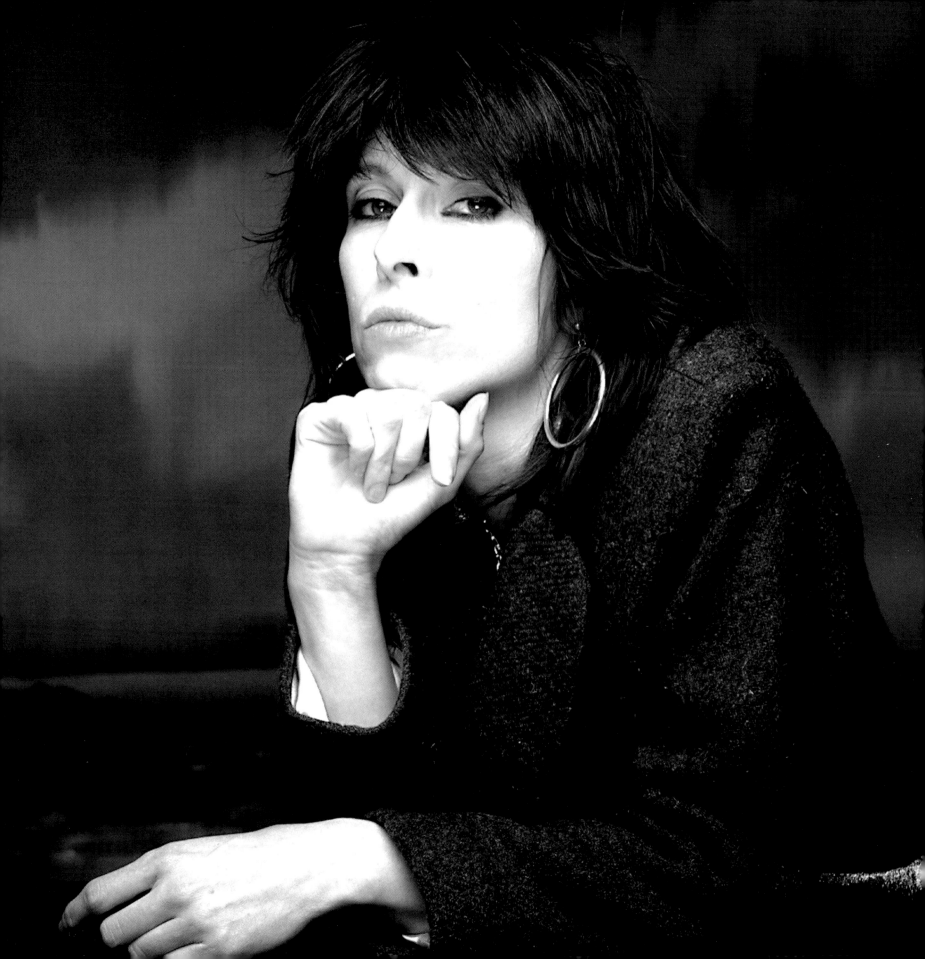

eva hesse

BY DODIE KAZANJIAN

EVA HESSE'S ACHINGLY BRIEF LIFE and her difficult, absurd, indelible art have given her a kind of mythic status in the art world. The fact that she died of a brain tumor in 1970, at the age of thirty-four, that she was strikingly beautiful, that she was a woman who took up sculpture, a field that was even more male-dominated than painting, that she and her family narrowly escaped the Holocaust, and that her mother committed suicide soon after all this has tended to skew perceptions of her work. She has been compared to Sylvia Plath, another hugely gifted woman who died too soon. Hesse's ambition was to be a great artist. Not a great woman artist but a great artist, period.

Since her first posthumous retrospective, in 1972 at the Guggenheim, her work has moved into major museums and collections around the world at prices that continue to rise exponentially. The San Francisco Museum of Modern Art paid $2.2 million for *Untitled (Not Yet)*, a hanging sculpture of testicular forms in mesh bags; a Hesse drawing today brings more than $100,000.

Eva Hesse was two years old in 1938, when she and her five-year-old sister, Helen, were put on a train taking Jewish children from Hamburg to Holland to escape Nazi persecution. Their parents joined them three months later. The family eventually made its way to London and then, in 1939, to New York. In 1952, Eva graduated from the School of Industrial Arts, where she had been voted most beautiful in her senior class. She was just sixteen, but she knew exactly what she wanted. "I am an artist..." she wrote to her father. Three years at Cooper Union led to two more at the Yale School of Art and Architecture, where she became the favorite student of Josef Albers, the director.

She began working with latex, a natural liquid-rubber substance whose malleability and surface texture appealed to her sense of touch. She also discovered other new materials. "Eva was going into tubs of fiberglass and polyester up to her elbows," LeWitt remembers. (Because these materials were so unstable, some of the later sculptures have deteriorated badly and can no longer be shown.) Her sculptures grew larger and wilder. *Accretion*, a lineup of fifty molded, fifty-eight-inch-tall fiberglass tubes, took up an entire wall. The skinlike texture and sensuality of the sculptures evoked visceral reactions from viewers and critics alike.

Legions of feminists continue to mine Hesse's work for evidence of the courage that refuses victim-hood. Hesse herself, who died before the women's movement established its major beachheads, had worked out her own feelings on that issue: "The way to beat discrimination in art is by art." She wrote in 1969, "Excellence has no sex."

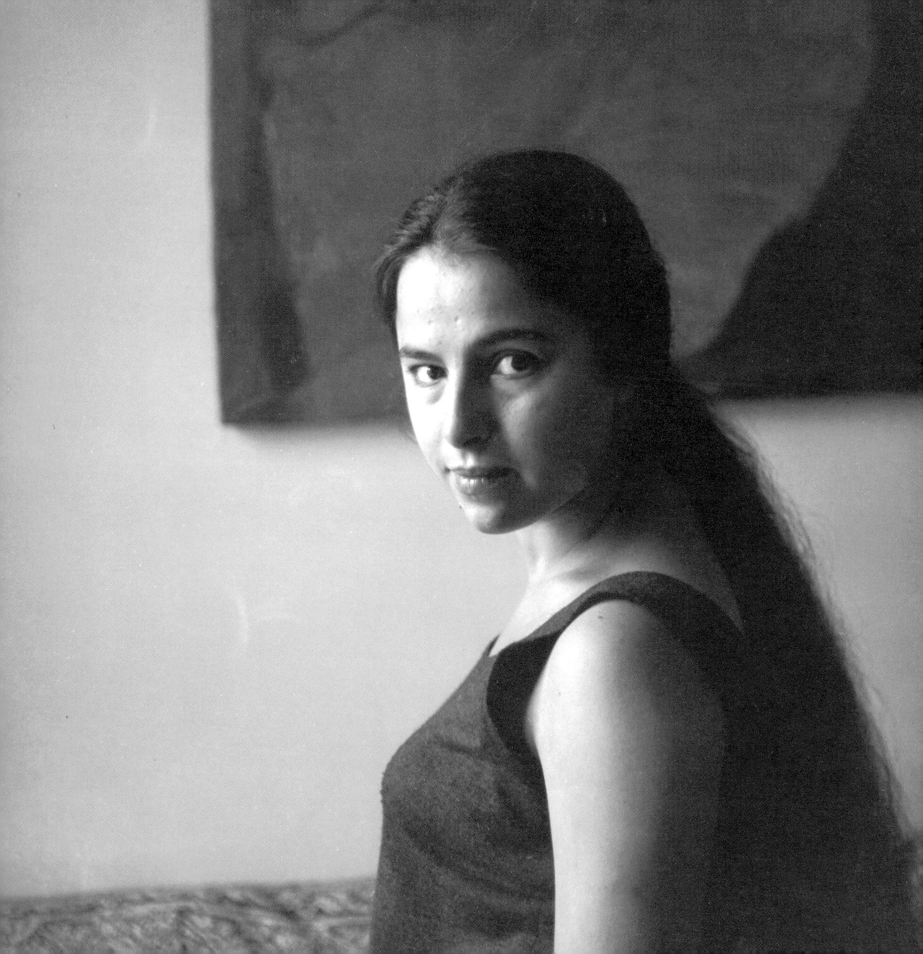

hillary clinton

BY GAIL SHEEHY

FROM BEHIND, THE SILHOUETTE OF THE freshman senator looks like that of a man. She has been unbound from the ill-fitting bodice of First Lady and refitted with long-jacketed pantsuits, allowing her to clasp her hands low, behind the back, in an authoritative military stance. Senator Clinton can now march about on the royal-blue carpet of the United States Senate and address "my distinguished colleague from New Mexico" as one among equals. She is constantly surrounded by men. Powerful men: the Senate leaders, committee chairmen, and floor managers. One moment she's in a strategic huddle with the Democratic leader, Tom Daschle, and liberal lieutenants Teddy Kennedy and Chris Dodd, the next she is striding across the aisle to schmooze with Republicans John Warner and Mike DeWine, to woo them into supporting her national teacher-recruitment campaign. If one didn't focus on the blond helmet hairdo we could all draw in our sleep, one might mistake Hillary Clinton for just one of the boys.

"She arrived in the Senate as an experienced, knowledgeable political leader," says Senator Kennedy. "She has a viewpoint....She is a hard worker, a good listener. She gets grudging respect on the other side of the aisle, but there is respect." Senator Dodd adds, "There were those who would have preferred she had been obnoxious. They are pleasantly surprised at themselves. They like her."

Hillary was chosen by Yale University students as the speaker for their Class Day in May [2001]. The threat of protests evaporated, and she was received as a pop-culture icon. She challenged the graduates to "dare to compete" and "dare to care." In interviews with many students, it became clear that most see her as a role model. Grant Chavin of the class of 2001 said, "Fifteen years from now I'll probably remember that Hillary Clinton spoke at my graduation instead of some random poet laureate or something."

George W. Bush followed Hillary, speaking the next day. Ignoring that 84 percent of the students voted against him in the presidential election and that 208 faculty members petitioned against his receiving an honorary degree, he ran into hundreds of peaceful protesters and was loudly booed. Once again, Hillary outshone the president of the United States—the person with whom she now sees herself daring to compete. In its first two hundred years, the Senate elected only six women (unless they stepped over their husband's dead body). Now there are twelve, plus a booster rocket named Senator Clinton. It's likely she's positioning herself for a run at the presidency—one can see burning in her eyes the Promethean fire.

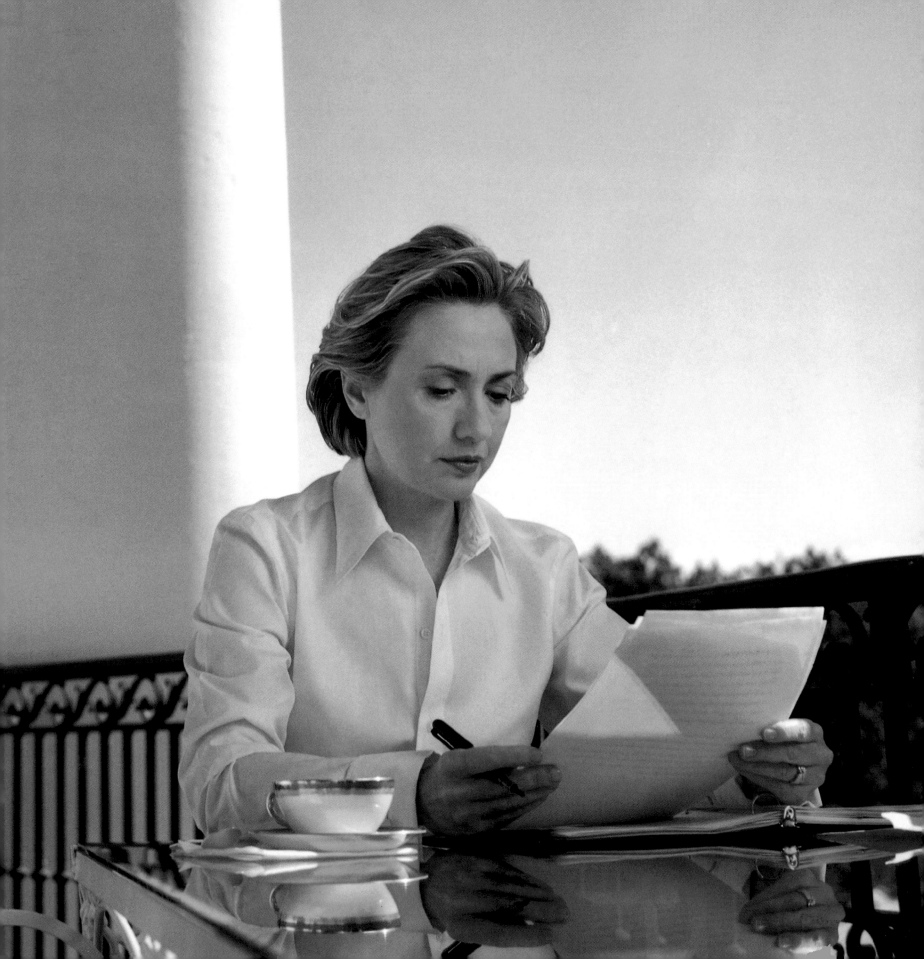

jamie lee curtis

BY MARIA SHRIVER

I
N A TOWN BUILT ON ILLUSION, the daughter of Hollywood royal couple Tony Curtis and Janet
Leigh is undoing a life of training in Tinseltown and debunking some myths. Jamie Lee Curtis, the
former "scream queen" of *Halloween* movie fame, says it can be pretty frightening getting trapped by
one's image. In the movie *Trading Places,* her character has a line: "All I got in life is this body, this face,
and what I got up here." That line foreshadowed the role her body would play in creating Curtis's image.
And she doesn't deny she was cast in movies like *Perfect* for a reason. The comedic talent was visible in
A Fish Called Wanda and *True Lies,* but so was her voluptuous body.

But in *More* magazine, she showed a before-and-after photo session, including a picture of herself in
what she calls her unglamorous skivvies, where photo and model are not retouched, revealing what she
calls "not great thighs" and a "soft tummy."

"Every commercial, every magazine, every TV show or movie, there are nothing but beautifully
coiffed, fabulously thin, toned people," says Curtis. "And I think that constant reminder that they
aren't—that there's something wrong with them—is the reason people are high-fiving me in stores."

"I had zero self-esteem growing up," says Curtis. "I was the daughter of a famous person, and so
basically everything is taken away from you. And no matter how many times I tried every day to be a real
human being, to do everything everyone else does, I was still a famous person's kid."

There was hardship along the way: her parents' divorce when she was young, a half-brother's death
from a drug overdose, and in recent years, an acknowledgment of her own substance abuse. She credits
her husband of eighteen years, Christopher Guest, a British baron and a successful film director, and her
two children with keeping her personal life on track. As for her professional life—Curtis says her
"other" career is doing just fine, that of a successful author of children's books.

"The books were the first thing that I actually felt the direct connection to feeling good about
myself," says Curtis. She hopes the messages of self-acceptance and self-worth will hit home with chil-
dren and their parents, and that she can inspire them as an example of someone who created success the
old-fashioned way—by earning it.

While the children who love Jamie Lee Curtis's books may never see her unretouched picture in *More*
magazine, she said that if she was going to promote self-esteem for kids, she felt it was important to
have the picture taken to "walk her talk."

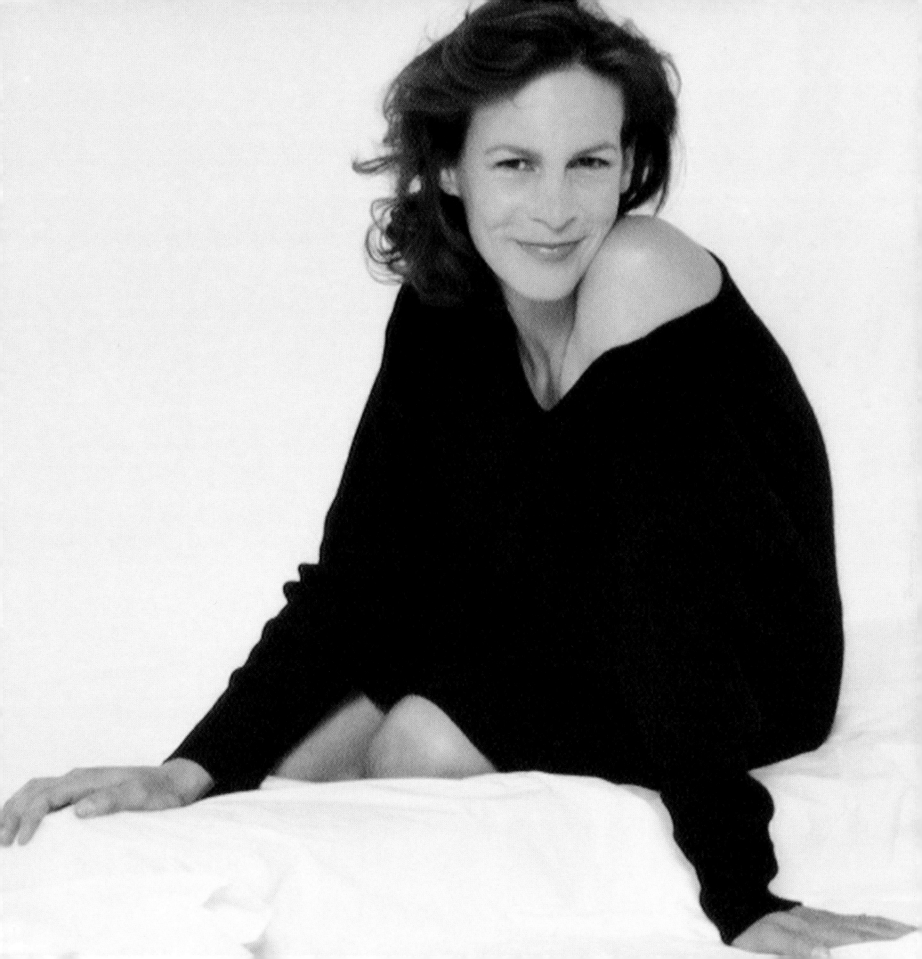

mitsuko uchida

BY KATHERINE AMES

MITSUKO UCHIDA IS SO FILLED WITH MUSIC she can't contain it. It flies out of her in unlikely places—airports, for instance. "I find people looking at me," she says, "because I'm singing. I do it all the time." They're songs without words, whatever music she happens to be playing in her head.

From the moment she strides onto the stage, it is clear that Uchida loves nothing more than playing the piano. Tall and thin, she hurls herself into the music much as a child might leap into a pile of leaves, her animated face reflecting constant astonishment at the mere existence of music. "What I would like to do with every composer is to play in such a way that people don't need to think while they're listening. They can do their thinking afterwards." Despite her musical exuberance and her enthusiasm in conversation, Uchida takes a Zenlike approach to her life and career. She schedules only fifty concerts a year, and she wants simplicity and experience to inform her playing. With age, she says, "one ought to be able to shed unnecessary things." She wears virtually no jewelry or makeup, has no car or TV, and lives on her own in a London house.

From her earliest childhood in Japan, Uchida says, "it was a quest to find out everything. I was full of questions that were not answered. I still have questions, but now I can wait for the answers." When she was twelve, already a fine pianist, she began studying in Vienna, where her diplomat father was posted. In her early twenties, she moved to England. "I worked out my own way of playing," she says. "I think I was trying to eliminate everything that was not mine. Growing up, you have a lot of outside influences. You can't get rid of them, but you can clarify and sort out what is yours. It takes a long time to get out of the world as other people see it."

She got out into the musical world by winning prizes in three important piano competitions. Nonetheless, she built her career cautiously, even though it meant early financial hardship. "When youngsters talk to me, I tell them, 'Get rid of your teachers and take a long-term view. I don't want to influence you; you have to discover. If you're good enough, then one day somebody will notice. Because the world is not full of wonderful things, and people are longing for good things.'"

"I've had some touching moments when adults come backstage and say, 'That was my first classical concert. Isn't it exciting?' And I say, 'Yes!'" And what better introduction to music than Uchida, whose reading of miracle workers like Mozart and Debussy is nothing short of miraculous.

alice walker

BY ALEXIS DE VEAUX

FOR OUT OF GRITS—POOR BEGINNINGS as a child of sharecroppers in Eatonton, Georgia, Alice Walker has invented a rich life. Born on February 9, 1944, a sensitive child who always needed peace, solitude, and gentle handling, scarred by the ugly trauma of nearly going blind at age eight when her brother shot her in the right eye with a BB gun, Alice receded into the imaginative beauty of books and poetry and writing. In 1961, she graduated at the top of her high-school class and went, with a scholarship, to Sarah Lawrence College. She traveled in Africa one summer, and when she returned to college, she was pregnant, alone, and scared. She had an abortion, and in the days that followed, she completed her first collection of poems, *Once.* Four years later, it became her first published book.

There would be many books of poetry and short stories and novels after that one. In 1983, at age thirty-nine, she became the first black woman novelist to win the coveted Pulitzer Prize for fiction for *The Color Purple,* a breath-snatching, artistic tour de force that is the story of Celie, a poor, young, barely literate southern black woman who articulates the brutality of life and of the men around her in a series of letters written to God. On the *New York Times* bestseller list for more than a year and a half, it also won the American Book Award for fiction. And although she had written nine books prior to its publication (and has written fifteen to date), *The Color Purple* became, ironically, Alice Walker's first widely discussed—and her most misunderstood—work.

Over four million copies of *The Color Purple* have been printed worldwide, it has been translated into twenty-two languages, became a Steven Spielberg movie in 1985, and was the subject of public demonstrations by angry readers and a hue and cry by the NAACP (whose Image Awards later recognized it as "one of the best stories of the year"). Alice Walker is still at the center of the so-called controversy over black male images in black women's literature. But her life and work have always been controversial, by other people's standards.

But Alice Walker lives by her own words. Controversial or not. Living good, inside and out. From head to toe. Dreadlocked hair and all. As she puts it, "I could not have written *The Temple of My Familiar* with straight hair, what I call 'oppressed hair.' No way. So I would like to say to other black women looking at me and my hair, 'This is as bad as it gets, honey. You don't have to be afraid. You don't ever have to worry about your hair going back. You can just be free.'"

diane keaton

BY SARA KINSELL

WAY BEFORE THE STUTTERING, fumbling, and kooky urban screen persona that everyone remembers in her Academy Award–winning role in the 1977 film *Annie Hall*, there was a woman and artist forming inside Diane Keaton who would speak for an entire generation of women. Call it feminism in a floppy felt hat. Call it Keaton's gift for liberating her onscreen women characters from unbearable self-repression. Before the Woody Allen epoch and dramatic roles in *Looking for Mr. Goodbar* and *Shoot the Moon*, it's worth noting that California-native Keaton (born Diane Hall) had her Broadway debut in the original cast of *Hair* and prowled the hallways of late 1960's television, appearing Zelig-like on episodes of *Mannix, Night Gallery,* and *Love, American Style.*

And then she came at us in 1972 with both barrels, as Michael Corleone's girlfriend Kay in *The Godfather* and as a best friend's wife bedded by the Bogart-obsessed movie critic played by mentor and companion Allen in *Play It Again, Sam,* adapted from Allen's Broadway play. While remembered for her high-strung and neurotic roles in later films, it was Keaton's durable and fresh feminism in *Play it Again, Sam* that created the romantic-comedy chemistry Allen has always milked from his Ideal Woman franchise players. Launched as Woody's Girl, Keaton ran the table in Allen's mid-1970's films, starring in *Sleeper, Love and Death, Annie Hall, Interiors,* and *Manhattan.*

Reflecting the spirit of the age and the Upper West Side, Keaton as Annie Hall fashioned the unisex, grab-bag look in hats, oversized shades, necktie, vest, and trousers as a jester wears motley and a mourner wears black. Savvy beneath her façade of eccentricity, Keaton was the leading lady who could match Allen's comedic timing and facial cues, balancing adroitly on screen as both subject and star. Not only could she keep up, she eventually left Allen behind to mull over his obsessions with sex, death, and revolving door's worth of ingenues.

She's worked opposite Pacino, Finney, and Beatty and alongside Hawn, Midler, and Streep. She's earned critical acclaim with directors like Allen, Coppola, and Bruce Beresford and more recently enjoyed commercial box office success in *Baby Boom, Father of the Bride,* and *The First Wives Club.* Always the improviser, Keaton has combined her love of photography and acting experience into yet another transformation: directing and producing music videos, documentaries, and feature films.

She has never married, she's a lefty, and she will surprise you every time you see her.

carly fiorina

BY ELIZABETH BRANDT

AN IMPRESSIVE ARRAY OF HARDCORE EXECUTIVE attributes won't necessarily earn or keep you a top slot in the business world. Especially when you are competing in a high-stakes industry in the intense environment of Silicon Valley, leading the world's second-largest computer maker. Especially with the added scrutiny that comes from being a woman at the top.

As chief executive officer and president of computer giant Hewlett-Packard Co., Carleton S. (Carly) Fiorina thrives where there is little margin or tolerance for error, where a flawless track record means nothing in the face of new challenges that arise with each new hour and day. Fiorina is known for those qualities that distinguish her in the high-pressure boardroom, on the shop floor, and in the cutthroat alleys of the marketplace: compelling vision; a personal touch that inspires loyalty; an extraordinary ability to conceptualize and champion business strategies while staying focused on operational results.

Already crowned the most powerful woman in American business by *Fortune* magazine, Fiorina steadily blazed her way to an impressive résumé of firsts in the world of business: first woman to head a Dow 30 company; first outsider to take the reins of computer giant HP. Then in the midst of leading a strategic mandate to breathe new life into the proud but aging Silicon Valley company, Fiorina masterminded HP's $20 billion acquisition of rival Compaq in the face of fierce resistance, a move packed with lessons about crisis management and the changing future of the high-tech sector.

Daughter of a federal judge and a painter, Fiorina attended schools in Ghana and England before earning a degree in medieval history and philosophy at Stanford University. Following a brief detour in law school at UCLA, Fiorina landed an entry-level job with AT&T at age twenty-five. Steadily rising through the ranks as star sales performer and executive, Fiorina successfully guided a spin-off company, Lucent Technologies, through an initial public offering worth $3 billion in 1996.

Throughout her career, Fiorina has been sent into troubled situations to provide a fix or turnaround. Armed with the power to make changes, a successful methodology, and the wisdom to know that listening must occur first, she is a believer that organizations already contain a lot of the right ideas and that the people who work there just don't feel as though they have the authority to get them done. Now Fiorina is recalibrating HP into the high-speed Net Age, playing to her leadership strengths: the ability to conceptualize and communicate sweeping strategies, the operations savvy to deliver on quarterly financial goals, and the power to bring urgency.

k.d. lang

BY LESLIE BENNETTS

YOU WOULDN'T NECESSARILY KNOW she's a woman at first sight. Tall and broad-shouldered, wearing a black cutaway coat flecked with gold, black pants, and her favorite steel-toed black rubber shit-kicker work boots ("Best boots I ever had. Got 'em for $25 at Payless"), she looks more like a cowboy. Her glossy dark hair is full but short, and when she tosses her head and strides across the stage on those long, strong legs, you suddenly realize she's moving with a kind of physical freedom you've never seen a female singer display onstage before.

All of which is irrelevant next to the voice, an octave-spanning wonder that soars and swoops and slides from such ethereal sweetness you find yourself holding your breath to a powerhouse blast that raises the rafters. It's the most amazing voice to hit pop music in at least a generation, and the audience is blown away. After years of trying to win acceptance as a country singer and being rebuffed by the overwhelmingly white, male, heterosexual, Christian, and not exactly welcoming Nashville establishment, she has finally burst through the categories and the restraints, and the ones who stood in her way will find themselves eating her dust.

When her collaborator, Ben Mink, first met her, at the World's Fair near Tokyo, he was taken aback by the self-assurance of this most unlikely creature, who was then at the beginning of her career. "She said, 'I'm going to be one of the world's biggest stars,'" he reports.

"I've always known that's what I was, that that was what I was going to be. It's not even like an immodest thing," she explains apologetically. "It's like somebody saying, 'I'm going to be a doctor.' It's not a big deal. I've known since as long as I can remember."

Given Lang's upbringing, the fact that she made that vision come true seems incredible. She was raised in the middle of the vast prairies of the Canadian West, near the border between Alberta and Saskatchewan, in a microscopic speck on the map called Consort. An eighteen-hour drive from where we are sitting, Consort has a population of 714 and is about as rural and isolated as you can get. It was 220 miles across the plains to either Edmonton or Calgary, the nearest major cities, "on gravel roads when I was a kid," Lang says.

She's well on her way, although sometimes she's the only one who doesn't think so. "I feel like I'm known and recognized and listened to, but I always feel like there are these major mountains I have to climb, creatively," she says. "I always feel like I'm just beginning."

bianca jagger

BY IRENE MIDDLEMAN THOMAS

MOST OF US THINK OF HER ONLY IN TERMS of what she hasn't been for fifteen years. Bianca Jagger is still the exotic dark-eyed beauty who entranced the world while captivating one of its hottest rock stars. But the glitz and glamour Jagger experienced as the wife of the king of bad boy rockers is far removed from her life now. She's much too busy rescuing children from Bosnia-Herzegovina, pursuing human rights transgressions in Central America, and traveling as the goodwill ambassador for the Albert Schweitzer Institute for the Humanities.

Born May 2, 1950, in Managua, Nicaragua, Blanca Pérez Mora Macías came from a well-to-do background. After graduating with perfect grades from convent school in Managua, she received a scholarship to the esteemed Institute des Sciences Politiques in Paris. While she studied political science there, she also became increasingly enmeshed in the high-profile social scene in Paris, which led to the fateful meeting with the leader of the Rolling Stones, Mick Jagger. The media seized upon the two from the start, haranguing them through their romance, their wedding in Saint-Tropez in 1971, the birth of their daughter the same year, and throughout the nine years of their marriage. She was known as a jet-setter, a disco queen, a fashion plate. She was featured in *Vogue* and *Harper's Bazaar.* She mingled with Andy Warhol, Yves Saint Laurent, and Truman Capote.

As her marriage floundered, her persona flourished. She had an acting career in film and television, studied filmmaking at New York University, and began to write for *Interview* magazine. Jagger evolved into a political activist stemming from the destruction and misery she witnessed while working with the victims of the devastating 1972 earthquake in her homeland. Throughout the 1970s, she became a voice for the voiceless in impoverished war-torn Central America. This eventually led Jagger to become involved with such human rights organizations as Amnesty International, Oxfam, SHARE, and MADRE. She has spoken on behalf of El Salvadoran refugees to the Subcommittee on Inter-American Affairs, lobbied against U.S. aid to the anti-Sandinista, and testified before the Helsinki Commission against the mass rape of Bosnian women by Serbs in Bosnia-Herzegovina.

Despite all that Jagger has fought for and achieved, she still eschews her "party girl" image. "To be honest, it has not been without great difficulty to get where I am today," she states. "I, more than anyone else, understand what it takes for a woman to emerge as her own person, to be accepted for who she really is. No matter how well known a woman is, it is very hard to shake the image of a famous husband. It takes determination, patience, and conviction. It has not been without struggle."

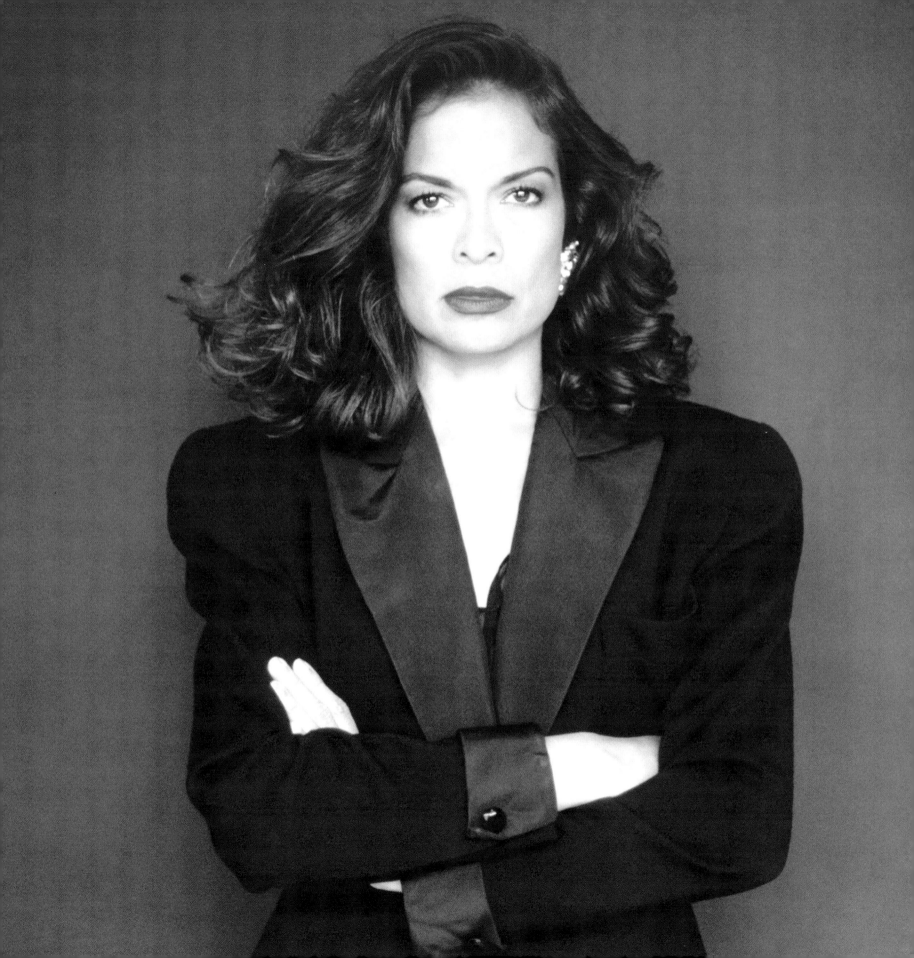

ann landers

BY MARGALIT FOX

EPPIE LEDERER, A.K.A. ANN LANDERS, was widely considered responsible for bringing the advice column into the modern era. She became Ann Landers in 1955, avoiding the quavering prose and Victorian euphemism of an earlier generation of newspaper sob sisters in favor of hard-nosed, often witty discussion of contemporary woes that, as she liked to say, "would twirl your turban." She advised millions of readers on problems as varied as acne, alcoholism, and AIDS, often in spirited competition with her identical twin sister, who wrote the advice column *Dear Abby*.

Her column was carried in more than 1,200 newspapers around the world, with a readership of ninety million. A 1978 *World Almanac* survey named her the most influential woman in the United States. "I would rather have my column on a thousand refrigerator doors than win a Pulitzer," she once said.

She was born Esther Pauline Friedman in Sioux City on July 4, 1918. In their youth, the vivacious, dark-haired Friedman twins were inseparable. In 1939, she married Jules W. Lederer, a hat salesman who later formed the Budget Rent-A-Car Corporation. In 1955, she noticed an advice column in the *Chicago Sun-Times* called *Ask Ann Landers.*

"I thought it was a good column, but not great," Mrs. Lederer recalled in a 1990 interview. "When I read it, I would cover up her answers and think about what I would have said if I had been Ann Landers." On an impulse, she called a friend who was a *Sun-Times* executive and asked whether she could help the advice columnist answer some of her mail. The timing was serendipitous. It turned out that the columnist, a nurse named Ruth Crowley, had died the week before.

Where earlier lovelorn columnists like Dorothy Dix had given measured, modest replies to discreet questions about courtship, the new Ann Landers was a wisecracking tough cookie out of Damon Runyon. She addressed correspondents as "Buster," "Honey," and "Bub," admonishing them to "kwitcherbellyachin'" over trivial complaints. Husbands distressed by wifely inattention were reassured, "Many are cold, but few are frozen."

She was partial to working in the bath, propping the mail on a marble shelf in the tub, tapping out the replies afterward on her I.B.M. Selectric typewriter. She could go through eight hundred letters, she said, in the course of a two-hour soak. Mrs. Lederer, who owned the rights to the Ann Landers name, often said she did not expect anyone to replace her after her death. [She died in 2002.] "There will never be another Ann Landers," she told the *New Yorker*. "When I go, the column goes with me."

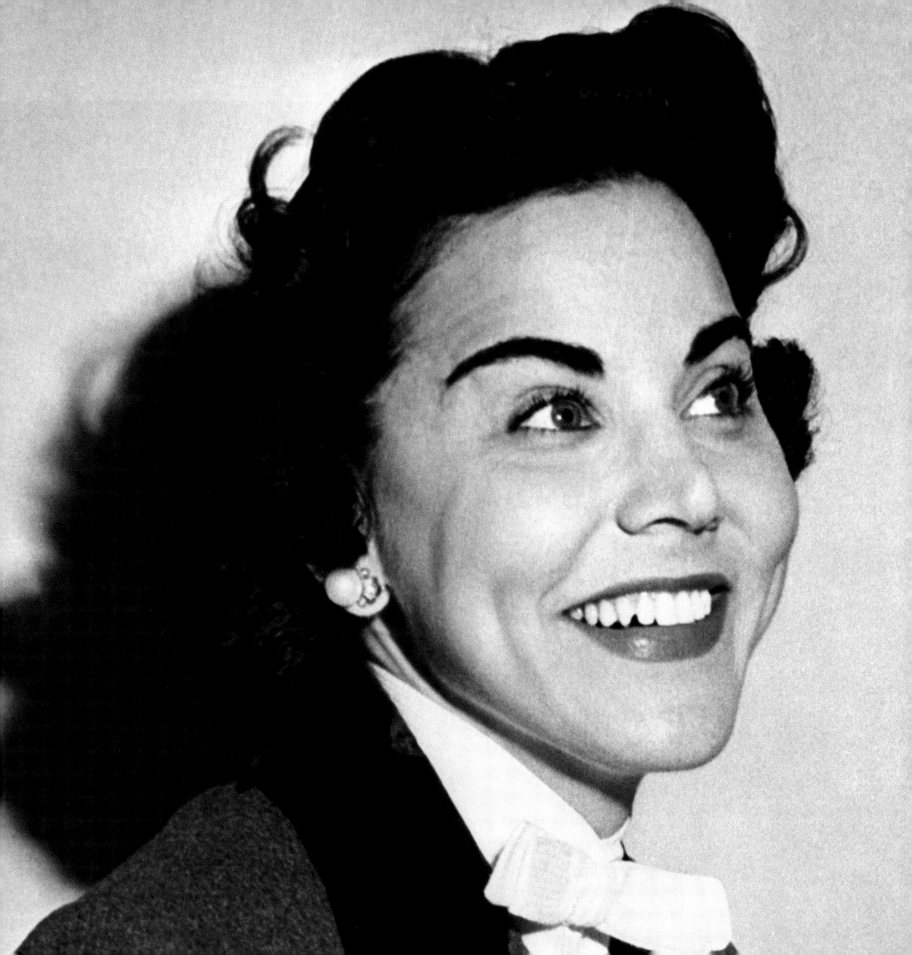

dorothy day

BY BETH RANDALL

DOROTHY DAY BEGAN HER ADULT LIFE as a Communist seeking religious truth and ended it as a Catholic influenced by Communist ideals. She anticipated liberation theology by some thirty-five years. She was born in Brooklyn in 1897 and raised mostly in Chicago. She attended but did not graduate from the University of Illinois. "I really led a very shiftless life, doing for the first time exactly what I wanted to do." In 1916, her family moved to New York and she went with them, to pursue a career as a revolutionary journalist. In 1917, she joined picketers in front of the White House who were protesting the brutal treatment of women suffragists in jail; they wound up serving thirty days in the workhouse at Occoquan.

"A woman does not feel whole without a man," Dorothy Day remarked, and in 1933, a man appeared in her life. Peter Maurin was an ex-peasant Frenchman, a compulsive pontificator, and a writer of dogmatic free verse. Under his influence she decided to put out a newspaper, to promulgate her left-leaning but newly religious perspective.

"We started publishing the *Catholic Worker* in May 1933, with a first issue of 2,500 copies. By the end of the year we had a circulation of 100,000, and by 1936 it was 150,000. Zealous young people took the paper out in the streets and sold it, and when they could not sell it even at one cent a copy, they gave free copies and left them in streetcar, bus, barber shop, and dentist's office.

In addition to the paper, Day opened a "House of Hospitality" in the slums of New York. Its purpose was to carry out those works that sound like such a good idea in theory: housing the homeless and feeding the hungry.

"What we would like to do is change the world—make it a little simpler for people to feed, clothe, and shelter themselves as God intended them to do."

By the 1960s, Day was acclaimed as the "grand old lady of pacifism," and left-wing Catholics such as Thomas Merton and the brothers Berrigan, as well as draft-dodgers, sought her out. The young people, however, were often dismayed by what seemed to be her reactionary stance on moral issues. She regretted her participation in the sexual revolution of the 1920s and was opposed to the sexual revolution of the 1960s. "This crowd goes to extremes...it is a rebellion against authority, natural and supernatural, even against the body and its needs, its natural functions of childbearing."

Dorothy Day died in 1980. After a lifetime of voluntary poverty, she left no money for her funeral. It was paid for by the archdiocese of New York.

bonnie raitt

BY MARY PAULSON

ACCOMPLISHED, YET NEVER SATISFIED. Respected, yet ever restless. On stage and in the studio, Rock and Roll Hall of Fame member Bonnie Raitt drives hard and relentlessly toward the heart of American music, forging elements of folk, rock, country, and pop into a firebrand form of the blues. With sixteen albums, eight Grammys, and thirty years of touring trailing like her trademark fiery strands of hair, the bestselling guitarist, singer, and songwriter summons added energy to promote social and musical causes, contribute to other musicians' recordings, and perform with her famous father, John Raitt.

Seldom out of the spotlight, Bonnie Raitt relishes her enduring role: "When the lights go down, it is the same gig as fifteen years ago. I have the coolest job of anyone I know." Exposure to the album *Blues at Newport 1963* at age fourteen had kindled her interest in blues and slide guitar, followed by local coffee-house gigs in the Boston area. Raitt left college to commit herself full-time to music. She soon found herself opening for the surviving giants of the blues, Mississippi Fred McDowell, Sippie Wallace, Son House, Muddy Waters, and John Lee Hooker.

Word spread quickly of the young, redhaired blueswoman, her soulful, unaffected way of singing, and her uncanny insights into blues guitar. Warner Brothers tracked her down, signed her up, and in 1971 released her debut album, *Bonnie Raitt*. Over the next seven years she would record six albums and receive three Grammy nominations. Despite a loyal following and critical acclaim, commercial success eluded Raitt. Warner Brothers found Raitt's mix of bar-band rock and oozy blues tough to market. Switching to Capitol Records and teaming with ace producer Don Was resulted in the 1989 release of *Nick of Time* (three Grammys), making Raitt a bestseller without selling her out.

Ever the Quaker activist, Raitt devoted herself to playing benefits and speaking out in support of a variety of causes, including stopping the war in Central America, the Sun City anti-apartheid project, the historic 1980 No Nukes concerts at Madison Square Garden, cofounding MUSE (Musicians United for Safe Energy), and working for environmental protection and the rights of women and Native Americans.

In 1992, Raitt wed television actor (and songwriting partner) Michael O'Keefe. But a lifelong intimacy with the blues keeps Raitt searching and maturing in her artistry. "Just because you have some of your dreams realized," she says, "doesn't mean you're necessarily going to be content."

ingrid betancourt

BY DINITIA SMITH

INGRID BETANCOURT, Colombian presidential candidate and bestselling author, was kidnapped by leftist guerrillas [in 2002]. Until her abduction, Betancourt was a presidential candidate of the left-of-center Oxygen party, which she founded.

Her memoir, *Until Death Do Us Part,* reads something like the script for a Costa-Gavras film, or, as *Publishers Weekly* has described it, a Tom "Clancy thriller" complete with a glamorous movie star–like heroine, almost single-handedly fighting corruption in the Colombian government.

The book describes Ms. Betancourt as a member of the oligarchy that has governed Colombia for generations and whose members are interconnected by ties of blood and friendship. The daughter of an ambassador to Unesco, she was raised mostly in Paris in an apartment on the Avenue Foch, where Gabriel García Márquez, Fernando Botera, and Pablo Neruda were guests.

After the 1989 assassination of the presidential candidate Luis Carlos Galán and the election of President Samper, she returned to Colombia to fight against the regime. In 1994, she ran for the House of Representatives as a member of the Liberal Party, passing out condoms on the streets of Bogotá with the slogan "The best way to protect us against corruption." She also went on a hunger strike against President Samper. At one point after she was elected, she made a speech before the Colombian legislature outlining the president's crimes, leaving her audience spellbound. "As I return to my seat, something curious in a Colombian context occurs: the silence continues, an impressive, stupefying silence, as if these men, who are too prone to violence, are temporarily broken."

Then, in 1998, disappointed at the reform efforts of the new president, she founded the Oxygen party and won a Senate seat with a record number of votes. During her career, Ingrid Betancourt has railed against right-wing death squads and narrowly missed being assassinated herself. She received death threats against herself and her family, including on one occasion a Polaroid photograph of a dismembered child. Finally, in 1996, an unnamed man arrived at her office. Ms. Betancourt writes, "'Your family is in danger,' the stranger says." She continues, "This time I can no longer play games." She sent her children to live with their father, at that time posted in Auckland, New Zealand. The decision devastated her, she writes. "Overcome by pain, I wander around the apartment that I bought for them, decorated for them, finding, every door, reminders of them, of their absence."

"I trust so much her strength," her daughter said in an interview. "I feel her energy from here."

faye dunaway

BY JOAN JULIET BUCK

FAYE DUNAWAY CAME BACK. On her way to Washington, D.C., just before Christmas 1986, she wrote in her journal, "Home at last." She had been living in London, married to the British photographer Terry O'Neill, in exile with him and their son, Liam. In the twenty years of her film career, she had moved from playing the raucous and unfulfilled outlaw Bonnie Parker, who said to Clyde Barrow, "With you I thought we were goin' places, but we were just goin,'" to portraying a series of queens and bitches, embodying along the way the first yuppie—Diana, in *Network*—and the last of the really mean stars, Joan Crawford, in *Mommie Dearest.* "I really wandered far afield," she says. "You know, the star machine."

Dunaway describes herself as "the last hat trick" of her first agents, Freddie Fields and David Begelman. "They wanted to make me a star—they'd done it before with Judy Garland and a number of other people—without anyone in Hollywood having seen me. I had four films in the can before anyone met me. Bonnie hit the fashion world, I got taken into the machine, and people ended up thinking I'd been a fashion model."

It is a shock to meet Dunaway in the flesh. She is beautiful. Not moviestar-comeback-but-still-attractive, really beautiful. Chatty and curious, self-mocking, her face and body a combination of angles that are harmonious however she places herself, whatever she does. [Film director] Barbet Schroeder put it succinctly: "She's the epitome of sensuality and mystery, of refinement and intelligence."

"In a lot of respects, there's an extremely vulnerable Southern girl inside me," she says. "What do you do when you're vulnerable? You cover it and pretend you're in control. I was able to act out an urbane façade: *Network, The Thomas Crown Affair*—these were heavy-duty women—and the culmination of that was Joan Crawford. It was a persona that I put on, but that was also put on me and that other women were putting on in order to appear forthright, aggressive, to do something in the world that would say, 'I'm not a bimbo.'"

"At first, I attempted to do the best work I could; I feel most clear and connected when I'm working—out there without a net, never sure if it's going to be good or not. And then came, 'What about my private life?' and then, 'I want a child, I want a partner.' Mine was the normal dilemma of the professional woman, but with the additional problem that I was so noticed."

A brief intermission in our conversation is spent talking about music—her favorite piece is Milstein playing Bach's "Chaconne," though she's partial to U2, Suzanne Vega, and Sting—and the necessity of down pillows. "You need something to hold on to," Dunaway says, "on the nights when no one's there."

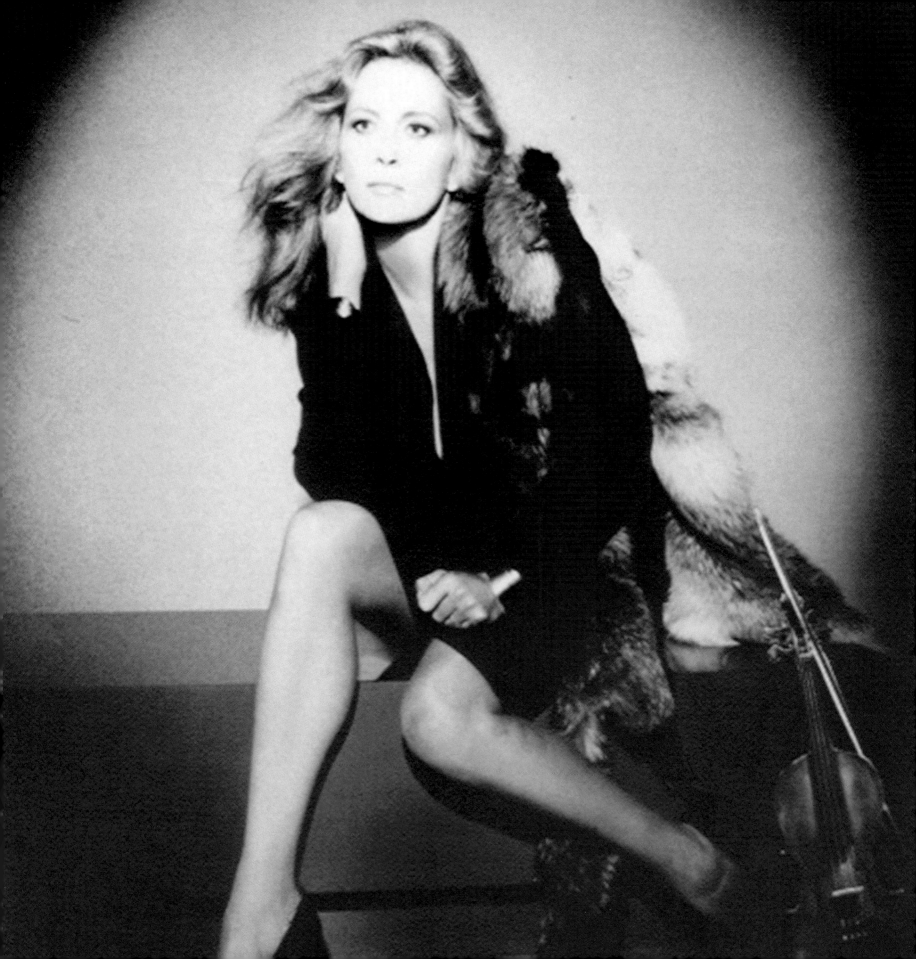

evelyn cisneros

BY STEPHANIE VON BUCHAU

VELYN CISNEROS TAKES YOUR BREATH AWAY. Contrary to the stereotype of the pale, childish, ethereal ballerina, Cisneros, who danced with the San Francisco Ballet, is dark, womanly, and as strong as an athlete. Her intensely dramatic stage personality has won her legions of fans, making even hard-to-please New York critics rave about her work. "Exceptional aplomb along with exceptional softness and refinement," says the *New Yorker.* "A star presence," says *Ballet News.*

Ever since she joined the San Francisco Ballet in 1977, Cisneros dazzled the San Francisco ballet world, and [she] danced the difficult dual roles of the swan queen and her evil nemesis in a very successful production of Tchaikovsky's *Swan Lake.* It wasn't always that easy. Born in Long Beach, California, the future prima ballerina was raised in the modest seaside community of Huntington Beach. "I was the only Mexican in my school until about fourth grade," she says, reflecting, "and it hurt when I didn't get invited to birthday parties or when the kids said things about the color of my skin." This isolation from other children added to the sensitivity and shyness of little Evelyn, and by the time she was eight, she recalls she was afraid to raise her hand in class to ask to go to the bathroom. Finally her mother took her to dance classes, hoping ballet lessons would cure her daughter's shyness.

When she was in junior high, she had to make a serious decision whether to try for a career in ballet or to prepare for college. "I was involved in softball, basketball, and volleyball," she says. "But I couldn't go on with those activities and study ballet every day. I chose dance."

Taught from early years to be abnormally attuned to their bodies and working exhausting hours with ballet masters and choreographers who sometimes treat them as children, many dancers develop a myopic view of the world, bound by diets, physical aches, and company gossip. But Cisneros is wide awake to the world with a remarkably balanced personality. Her mind is quick, her conversation measured but frank, and her laugh spontaneous and vibrant. Far from being narcissistic, she seems at ease with her body, which is slender but strong and womanly. Her partner, Anthony Randazzo, calls her "a natural."

This prima ballerina, whose name actually means "keeper of swans," believes she was destined to dance the Swan Queen—to become one of the great ballet dancers of her time. "It is true," she says. "Everything is meant to happen. I believe in the divine plan of God."

nora ephron

BY DINITIA SMITH

TO THE MEN WHO RUN FILM STUDIOS, says Nora Ephron, "a movie about a woman's cure for cancer is less interesting than a movie about a man with a hangnail." The typically sharp-tongued director is nothing if not a survivor in a line of work largely occupied by men. How, then, has she succeeded? Above all, she is tough. Small, edgy, intense, she is the sort of person who compels an interviewer to tread warily lest her head be bitten off. Her personality daunts even her closest friends. "In many ways Meg [Ryan] and I are sort of scared of Nora. You don't want to disappoint her," said [Tom] Hanks. "You don't want to go neck and neck with Nora in a battle of wits."

Ms. Ephron grew up surrounded by famous and powerful folk. Her parents, Henry and Phoebe Ephron, wrote *Carousel, Daddy Long Legs, Desk Set,* and one play loosely inspired by their daughter Nora's life, *Take Her, She's Mine.*

She was born the eldest of four daughters on the Upper West Side of Manhattan. The Ephrons were a family that valued verbal jousting, and in an article in *Vanity Fair* one of her sisters compared the family dinner table to the Algonquin Round Table. The Ephrons moved to Beverly Hills when Ms. Ephron was three. She was hardly the sort of kewpie-doll girl fashionable in 1950s Hollywood. After college, she became a journalist at the *New York Post.* Her semiautobiographical novel, *Heartburn,* published in 1983, was largely an account of her second marriage, to the Watergate journalist Carl Bernstein. When Ms. Ephron was seven months pregnant, she learned that Mr. Bernstein was having an affair, and she delivered her baby prematurely. In *Heartburn,* Ms. Ephron describes the main character's unfaithful husband as "capable of having sex with a Venetian blind."

Ms. Ephron had been writing screenplays, work that enabled her to be at home with her children. The same year, 1983, that *Heartburn* was published, *Silkwood,* her screenplay with Alice Arlen, was made into a movie, directed by Mike Nichols. *When Harry Met Sally* and *Sleepless in Seattle* won her Academy Award nominations for best original screenplay.

Her movie *You've Got Mail* is a paean to the Upper West Side, filmed on its streets and inside its brownstones. She still lives on the Upper West Side—in an unusually large apartment by Manhattan standards—with high ceilings, delicate moldings, crystal chandeliers, and velvet covered pillows, not far from her favorite food-shopping haunts, Zabar's and Citarella. Her next film, she hopes, will be about the 1950s reporter Marguerite Higgins. "It's a movie about a difficult woman. That's interesting to me."

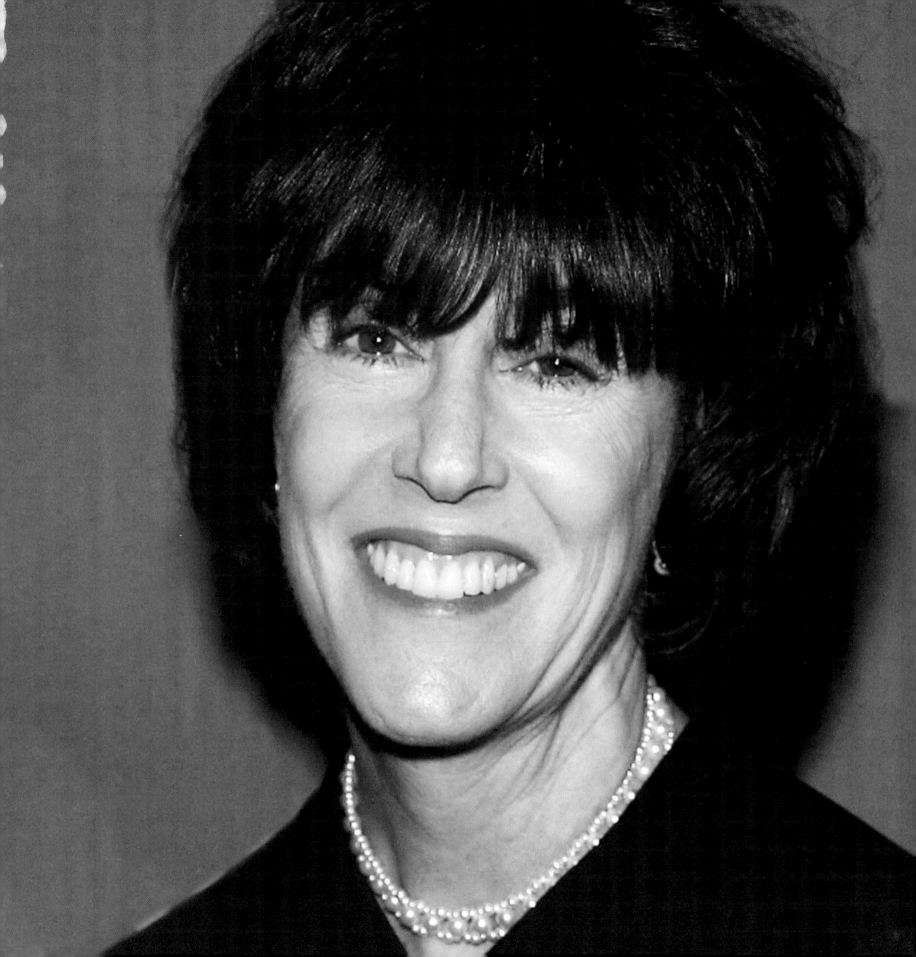

maria callas

BY HOLLY BRUBACH

MARIA ANNA SOFIA CECILIA KALOGEROPOULOS—Callas's real name—was born in New York in 1923, the daughter of poor Greek immigrants. Her love of music stemmed from listening to classical music recordings and the radio as a child, and her parents scraped together the money to give her singing and piano lessons. When her parents' marriage fell apart, Maria's mother moved back to Greece, where, recognizing her daughter's potential, she enrolled her as a student at the prestigious Athens Conservatory.

As an ungainly and rather dumpy teenager, Maria was already struggling with the weight problems that were to dog her career. Her voice was also flawed and, at times, uncontrollable, but Callas overcame both problems with sheer determination. She trained her voice relentlessly and shed pounds to transform herself into the immaculately groomed and elegant star we remember today. But it was only when she secured an engagement to sing in *La Gioconda* at the 1947 Opera Festival in Verona, Italy, that she finally gained international recognition.

It was here she met Giovanni Battista Meneghini, an opera-loving industrialist twenty years her senior, whom she married two years later. Meneghini also became her manager, but while he is credited with nurturing her career, it was Aristotle Onassis who stole her heart. Callas first met the wealthy shipping magnate at a party in Venice in September 1957. In July 1959, Onassis invited the singer and her husband to join him and his wife, Tina, on his sumptuous yacht, *Christina*. By the end of the cruise, Callas and Onassis had become lovers, and their respective marriages were over. During the next seven years, Callas drastically curtailed her performances to enjoy the high life with Onassis, who cared little about her talent. It was her fame that mattered to him, as he wooed her with promises of marriage and unimaginable luxury. She was devastated when the millionaire then publicly abandoned her for the widowed Jacqueline Kennedy in 1968.

Humiliated and deeply hurt, Callas broke down and shut herself away in her Paris apartment. Though she attempted to revive her career, her voice was failing and life had lost its meaning. Onassis swiftly realized that his marriage to Jackie Kennedy was a disaster and attempted to rekindle his relationship with Callas. She refused to have him back. By the time Onassis died in March 1975, Callas was a virtual recluse, tortured by doubts as to whether she had left her mark on the world.

She needn't have worried. Twenty-five years after Maria Callas's tragic death, she remains the consummate opera singer.

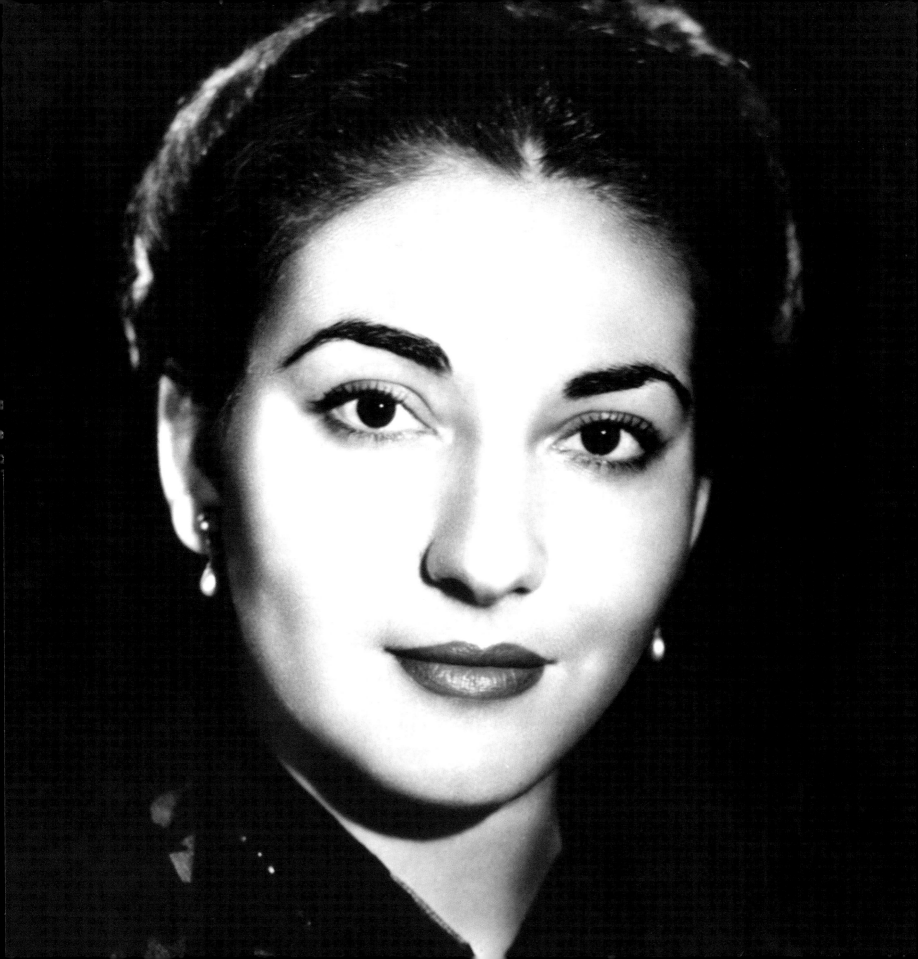

barbara jordan

BY MOLLY IVINS

FINDING BARBARA JORDAN IN THE DIRECTORY of distinguished Americans is easy. She was always a First and an Only. First woman, only black: in the Texas Senate; in the Texas Congressional delegation, from the entire South. She served on the Judiciary Committee during the decision on Richard Nixon's impeachment. Her great bass voice rolled forth, "My faith in the Con-sti-tu-tion is whole, it is com-plete, it is to-tal." She sounded like the Lord God Almighty, and her implacable legal logic caught the attention of the entire nation.

The degree of prejudice she had to overcome by intelligence and sheer force of personality is impossible to overestimate. She wasn't just black and female; she was homely, she was heavy, and she was dark black. When she first came to the Texas Senate, it was considered a great joke to bring racist friends to the gallery when BJ was due to speak. They would no sooner gasp, "Who is that nigger?" than she would open her mouth and out would roll language Lincoln would have appreciated.

Born and raised in the fifth ward of Houston, the biggest black ghetto in the biggest state, she graduated magna cum laude from Texas Southern University and went on to Boston University law school. Jordan was so smart it almost hurt. Jordan always knew what she was talking about and almost always won.

As it happened, the night BJ spoke to Congress in favor of impeaching Richard Nixon was also the last night of the Texas legislative session. Came BJ's turn to speak and everyone back in Austin—legislators, aides, janitors, maids—gathered around television sets to hear this black woman speak on national television. And they cheered for her as though they were watching the University of Texas pound hell out of Notre Dame in the Cotton Bowl.

In the last fourteen years of her life, BJ was a magnificent teacher at the LBJ School of Public Affairs. The only way to get into her classes at the University of Texas was to win a place in a lottery. For many students, she was the inspiration for a life in public service. No perks, no frills, no self-righteousness, just a solid commitment to using government to help achieve liberty and justice for all. Her role as a role model may well have been her most important. One little black girl used to walk by Jordan's house every day on her way to school and think, "Barbara Jordan grew up right here, too." Ruth Simmons [went on to become] president of Smith College.

Today Barbara Jordan is the first and only black woman resting in the Texas State Cemetery.

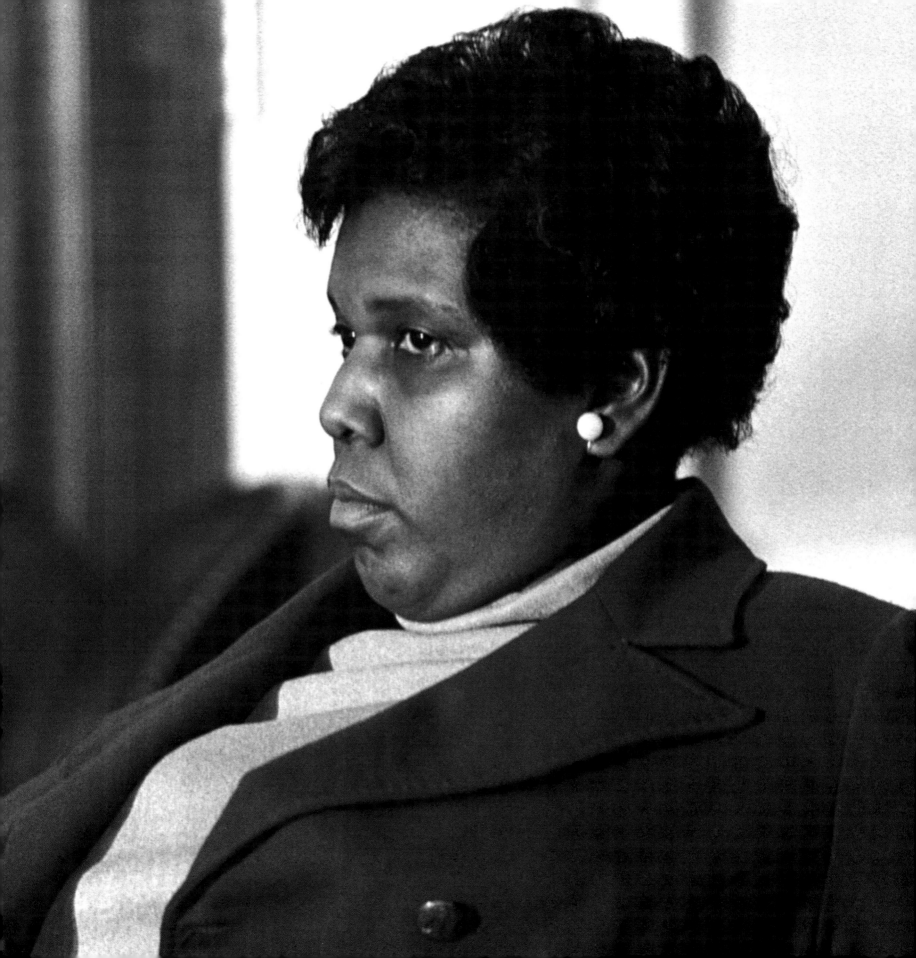

jessica lange

BY MARINA CARROLL

SEARCH THE FILM VAULT of the last twenty-five years, and you may not find another actress other than Jessica Lange with such a wealth of raw verve and versatility. Blending sensual beauty with inner strength, she's the Dream Girl every man wants to have along for any kind of showdown.

Watch any of Lange's more than twenty-five films and you'll find yourself amazed by the pure voltage she brings to her performances. That trademark tenacity and sexually charged mystique. It's like the camera has been waiting for her all along.

Describing Lange's performance in the 1986 comedy *Crimes of the Heart*, film critic Pauline Kael observed, "Lange goes beyond the individual character...she's a smiling tough cookie in a blue denim jacket and a short skirt that sets off her long legs—a rowdy, down-to-earth American archetype, everybody's favorite waitress." An allusion certainly to Lange's role of Cora in the 1981 remake of *The Postman Always Rings Twice*, as well as homage to Lange's working class roots and her ongoing quest to thrive outside the Hollywood system.

Born in 1949 in tiny Cloquet, Minnesota, into a transient family, Lange fled to study art and travel with a Spanish photographer named Paco Grande. Ever the seeker, Lange moved from studying mime in Paris to modeling for the Wilhelmina Agency in New York City, leading to a wild-card role as the female lead in *King Kong*, a remake of the 1933 classic.

In 1982, Lange earned the distinction of a double [Academy Award] nomination for Best Actress in *Frances* (she lost out to Meryl Streep) and Best Supporting Actress in *Tootsie* (she won). She brought Patsy Cline to life in the acclaimed *Sweet Dreams* and in 1992 took home the Best Actress Oscar for her role in *Blue Sky*. Early success enabled Lange the credibility and opportunity to choose film roles carefully and carve out a lifestyle that is in character and consistent with her beliefs. She lives in Minnesota, not far from where she was born, raising a daughter by Mikhail Baryshnikov and two children by *Country* costar and companion Sam Shepard. Lange is an activist who campaigns for Democrats and against wars and serves as a goodwill ambassador to Africa for the United Nations.

Distancing herself from the box office–driven commercial aspects of Hollywood, Lange has the luxury of working on independent and foreign film projects and a new role as a stage actress. It's not just the characters she brings to life, but the life that it brings to her. In *King Kong*, playing a budding actress discovered on several levels, Lange delivers a line of telling insight: "It's true. A movie can save your life."

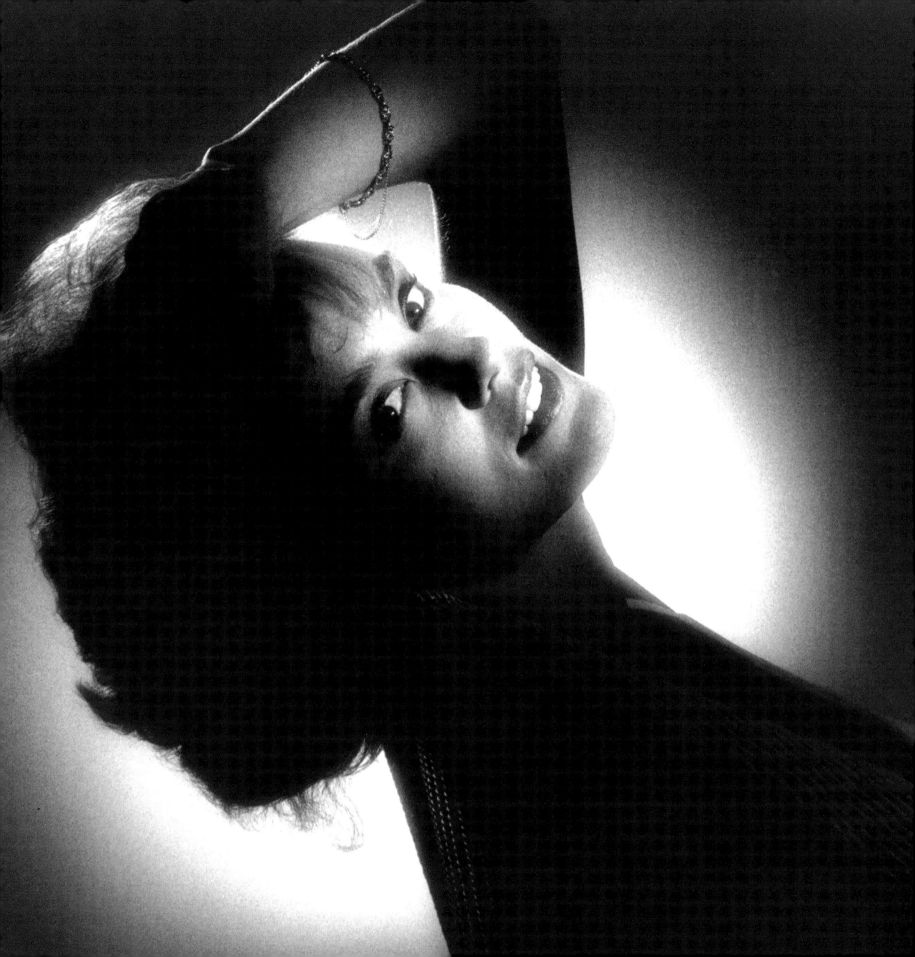

j. k. rowling

BY LINDA RICHARDS

WHEN J.K. ROWLING BEGAN WRITING the novel that would become *Harry Potter and the Sorcerer's Stone* in the early 1990s, she didn't see fame in her own crystal ball. "I thought I'd written something that a handful of people might quite like," she said at a press conference. "So this has been something of a shock."

The "this" she speaks of is the sudden and almost overwhelming fame that has accompanied the unprecedented success of her Harry Potter series of books. The sort of fame western society generally reserves for rock stars and well-known actors, not ever—until now—for authors of books for children.

Joanne Kathleen Rowling was born in July 1966 in a town in England called Chipping Sodbury. At present, she lives in Edinburgh, Scotland, with her daughter Jessica.

Though the seeds of Harry had been sown as early as 1990, Rowling didn't put all of the pieces together and start writing in earnest until the mid-1990s when she was living in Edinburgh, raising Jessica alone. Not able to afford even a used typewriter—let alone a computer—Rowling wrote the earliest drafts of *Harry Potter and the Sorcerer's Stone* in longhand.

"I knew I wanted to get published. And, in truth, writing novels is something you have to believe in to keep going. It's a fairly thankless job when no one is paying you to do it. And you don't really know if it's ever going to get into the bookshops, so I really did believe in it. But I was also very realistic. I knew the odds were not on my side because, an unknown author, you know? It's tough. It's tough the first time to get published, so I persevered. I loved writing it, and I felt that I just had to try."

Throughout the nearly incredible rise to popularity of the Harry Potter books, Rowling has been asked if she was aware of being part of a crusade for reading and literacy. She denies it, but not without some pride. "I wrote the book for me. I never expected it to do this. That it's done it I think is wonderful. If I can honestly think that I've created some readers, then I feel I really wasn't taking up space on this earth and I feel very, very, very proud. But I didn't set out to do that, and my first loyalty, as I say, is to the story as I wanted to write it."

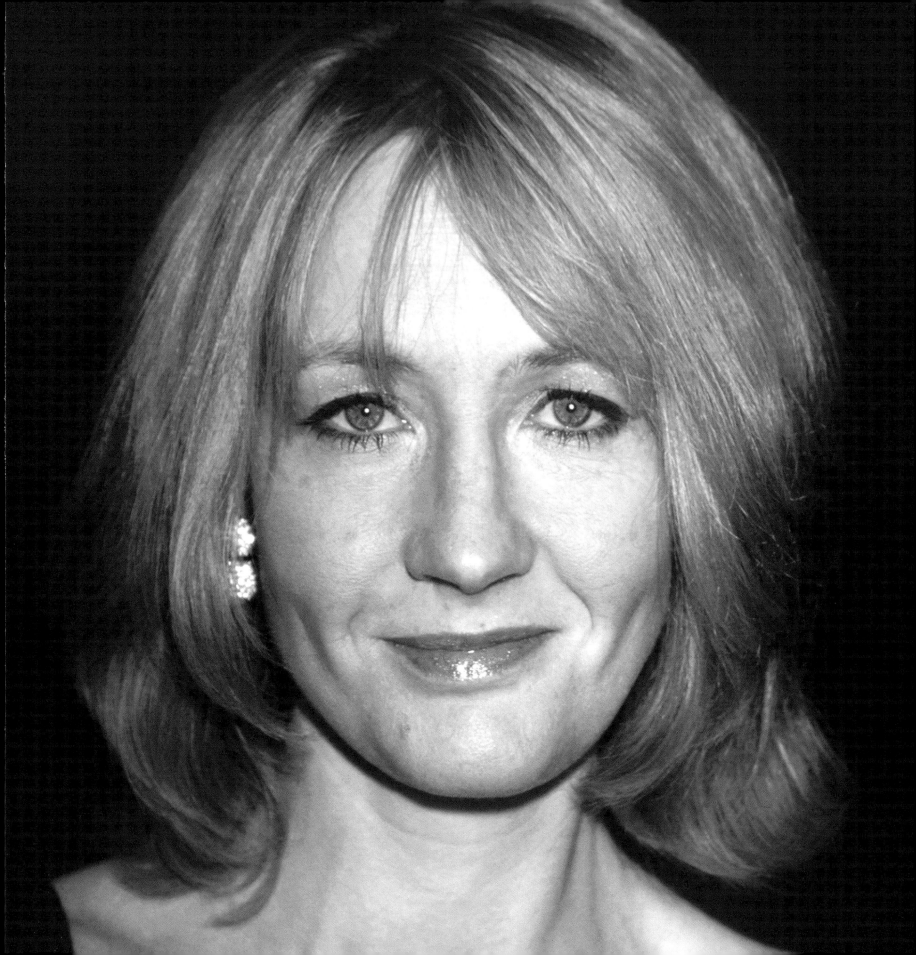

patsy cline

BY ROSEANNE CASH

M Y MOTHER SAID HER NAME with slightly pursed lips: "Patsy"—no last name needed, vowels squeezed a little by disapproval but the tight mouth holding back a barely contained thrill. Patsy Cline was wicked and fabulous when both qualities really meant something, before they were cheap ideas used to market more flaccid talents. She was a source of fascination, distrust, and raw, if hidden, admiration. But not judgment; there was nothing to attach judgment to because she, Patsy, did not judge herself. Those with real memories of her have been somewhat revisionist in their collective retelling. She was so damned great (also in the pre-marketing sense of the word) that perhaps they felt a need to polish and repair her wild and willful personality in order to complement the magnitude of her talent, particularly since she was a woman in an era that did not suffer female unaccountability gladly.

What is the fate of a woman who is truly and spontaneously alive, who is rooted in her body like a redwood in the earth, who is in command of a startling sexuality that infuses everything, and who is the vehicle for a preternaturally affecting voice that both reveals and obscures her essence? Patsy Cline's biographical fate was blunt and almost predictable: she died in a plane crash at the peak of her success, in March 1963 at the age of thirty. Her cultural fate has been grander, ever expanding, perhaps given impetus by her sudden death but not defined by it. She had extraordinary enough gifts to become a profound source of inspiration to those of us without immediate memories of her, those of us whose voices weren't so full-bodied and fully formed from the beginning and whose values were not so exquisitely self-determined. Her confidence and lack of self-consciousness alone would have fostered myth, but because of her remarkable talent, she has become part of the fabric of our musical destiny (and a source of frustration for those of us who seem mere vocal dilettantes by comparison). We have spent the last thirty years paying homage in all kinds of forms, both serious and irreverent, including the feature film *Sweet Dreams* and revivals, like all-Patsy nights at the Ryman Auditorium in Nashville. But in my private quandaries, musical and otherwise, it gives me a lot of satisfaction to connect the teeming, spread-all-over-the-place personality to the gifts she possessed. She lived a life utterly her own, messy and self-defined, and it all fed and merged with that voice.

My mother tells me that somewhere in the blackout of early childhood I had an encounter with Patsy Cline. I may spend the rest of my life trying to remember it.

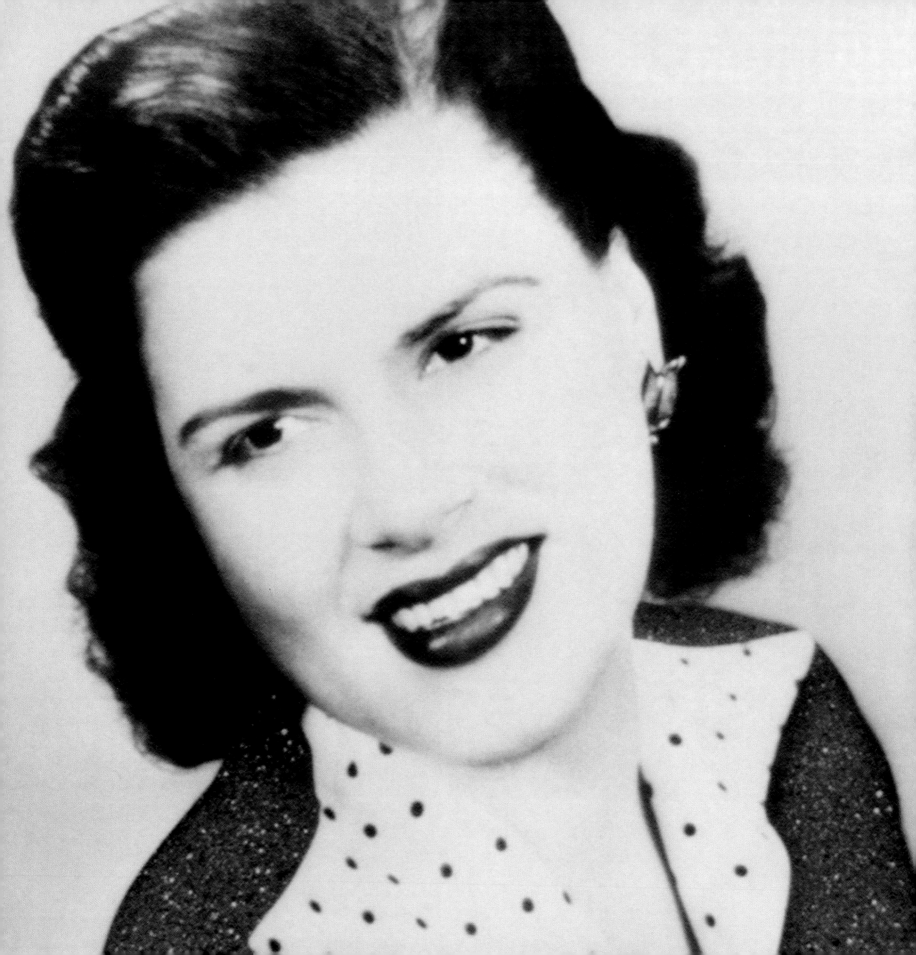

bessie smith

BY SUSANNAH MCCORKLE

I F HER VOICE WAS HUGE AND HEAVY, her use of it was remarkably nimble. Her timing was solid, dynamic, and exciting, no matter how little rhythmic support she got from her musicians. Her phrasing was full of surprises, some words compressed, others tantalizingly strung out. She would twist out an evocative word for up to six notes to dramatize it: *home, hate, long, alone.* There was honest heartbreak in those vowels.

Bessie was born in April, probably in 1894, in the Blue Goose Hollow section of Chattanooga, Tennessee. At the age of nine, Bessie began to sing in the street for small change, accompanied on the guitar by her other brother, Andrew. When a traveling show came to Chattanooga in 1912, he arranged an audition for his little sister, and she was taken on as a dancer.

Bessie was coming up in the black entertainment world at a propitious time. World War I was ending, and a relieved public began to relax with illegal liquor and new music, urban blues and hot jazz. A black songwriter, Clarence Williams, arranged a 1923 audition for her with the head of race records at Columbia, Frank Walker. Walker signed her, and Williams negotiated her contract.

Alberta Hunter had recorded *Down Hearted Blues* and done well with it the year before, but Bessie's version did far better, selling 780,000 copies within six months. Suddenly Columbia's biggest moneymaker, she signed a new, far more lucrative contract—$1500 a week for an expanded show with more elaborate sets and a bigger cast.

In January 1925, she recorded with the stunningly talented young Louis Armstrong, and their rapport was extraordinary. The records they made—"St. Louis Blues," "Reckless Blues," "Sobbin' Hearted Blues," "Cold in Hand Blues," and "You've Been a Good Ole Wagon"—are among her very best. In a *Voice of America* broadcast that Armstrong recorded late in his life, he played Bessie's "St. Louis Blues" and praised her artistry. He recalled that at that session he had needed to break the first hundred-dollar bill he'd ever received. Bessie promptly lifted up her skirt and took wadded bills out of little pockets in a carpenter's apron full of cash.

This great artist belongs to everyone who responds to her. She transcends boundaries of race, nationality, generation, and category. Her work is available, accessible, and life-enriching. For maximum benefit, the beginning listener is advised to sing along with her as loudly as possible on such timeless lines as "I'm a red hot woman, full of flamin' youth," "Mr. Rich Man, Mr. Rich Man, open up your heart and mind," and "It's a long old road / But I know I'm gonna find the end."

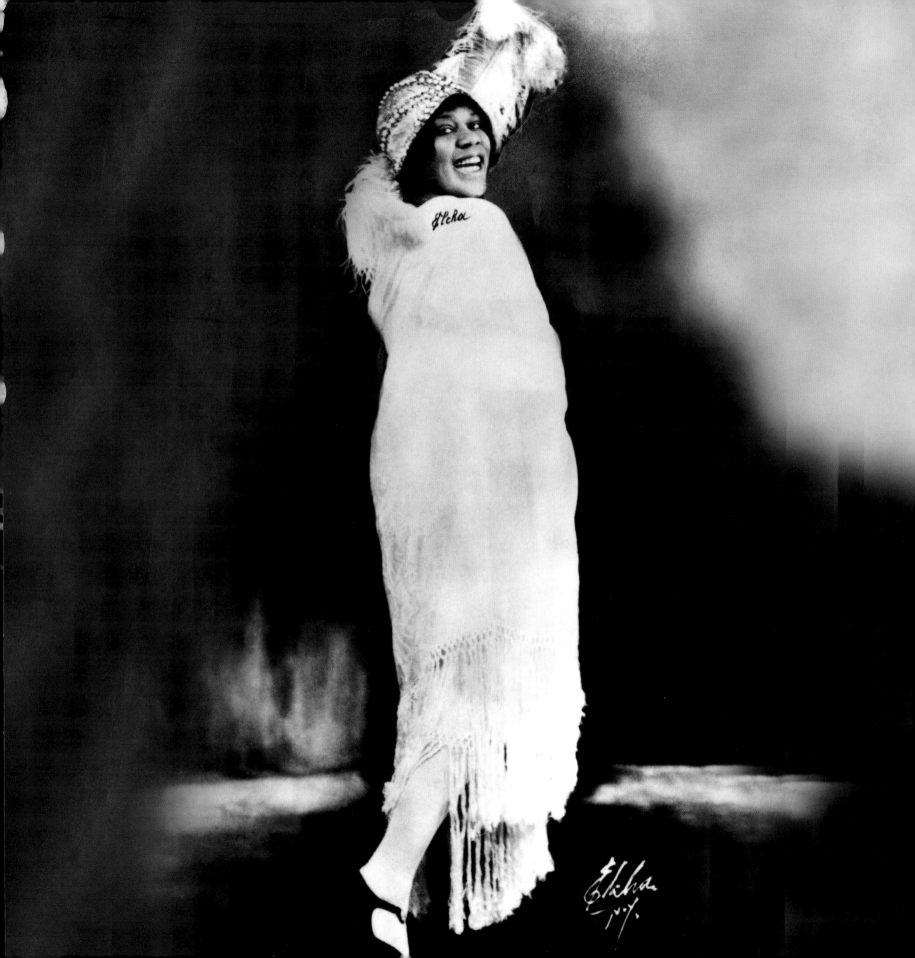

cate blanchett

BY MELISSANDE CLARKE

WHEN ANTHONY MINGHELLA, writer-director of *The Talented Mr. Ripley,* began his search for an actress, he wanted someone "like Cate Blanchett," he says, "someone with her distinctiveness. But I knew she wouldn't do it." The part was small, and Blanchett was white-hot—fresh off *Oscar and Lucinda* opposite Ralph Fiennes and approaching a Golden Globe win and Academy Award nomination for *Elizabeth.* He was amazed when she said yes.

"It told me a lot about her," he says now. "Her compass is not steering her toward a star vehicle; it's steering her toward movies and directors who intrigue her."

Blanchett graduated from NIDA [National Institute of Dramatic Art in Sydney] in 1992 and two years later, at twenty-five, won the Sydney Theatre Critics Circle Award for her role opposite Geoffrey Rush in David Mamet's powerful two-hander *Oleanna.* She tackled the roles of Miranda in *The Tempest* and Ophelia in *Hamlet,* earning a reputation as an inventive actress who wasn't afraid to take risks. In 1996, she made her first feature film, Bruce Beresford's World War II P.O.W. drama *Paradise Road,* and managed to stand out in a crowded cast that included Glenn Close and Frances McDormand. The word was out. Australian director Cherie Nowlan next hired Blanchett as the perfect blond bride in her black comedy *Thank God He Met.* "I couldn't stop looking at her," Nowlan recalls. "She'd covered her face in white pancake makeup, but I could see underneath that she was very beautiful." Soon she went into orbit. And her now hectic schedule takes a toll. She and her husband, Upton, whom she married in 1997, travel together as much as possible and have been living out of "a suitcase the size of a small African village" for the past two years. The beachside apartment they own in Sydney is rented out, and home is more often than not a hotel room or a part-time apartment on the road. Although the constant traveling is debilitating, having Upton around restores her sanity. "He's incredibly supportive," says Blanchett. "I wake up in the morning, and I can't quite believe my luck."

Be the first to tell her she was nominated one of *People* magazine's fifty most beautiful people in the world, and she affects mock relief, saying, "I can breathe easy." Blanchett is remarkably nonchalant about the trappings of fame and her good fortune. As far as she's concerned, it's business as usual—she's still seeking out interesting roles; she's just had a pay raise. "I've come out of working in theater, where you earn absolutely no money and you can't pay your electricity bill, to being able to buy a leather jacket and not having to worry about it," she says. To the rest of the world, it's obvious: Blanchett is making quite a name for herself. "She's heart-stoppingly good," says Minghella. "An exhilarating actor."

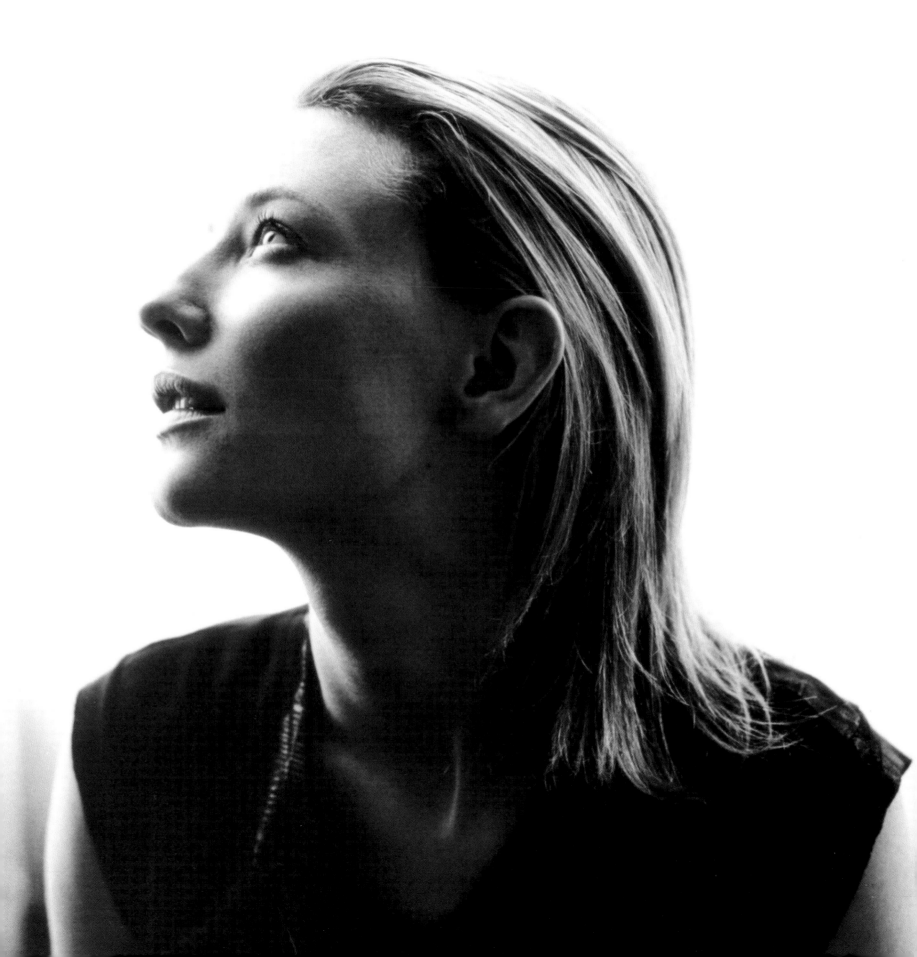

rebecca lobo

BY SALLY JENKINS

To UNDERSTAND THE ENDURING POWER of the high heel, you must meet Rebecca Lobo. Until you have witnessed the six-foot-four Lobo cruising on a pair of three-inch stacks, you haven't grasped the true nature and fascination of height. For Lobo, the high heel is no mere adornment. It is a statement of mission and of self. She habitually wears them, as she did one recent spring night when she appeared at a banquet at St. John's University in New York to deliver the keynote address to three hundred collegiate women athletes. Lobo sauntered through the room in her towering black platform heels, signing autographs, her custom-made black suit with the flared sleeves swirling around her. The room, full of supposedly empowered female athletes, was spellbound. While most other big women try to seem smaller, Lobo wants to be taller. "I figure six foot four, six foot six—what's the difference?" she says. "I might as well have style."

Style she has. As the WNBA begins its third season, Lobo remains the "It Girl" of women's basketball. Sheryl Swoopes may have the shots, and Cynthia Cooper may have the championship rings, but if you want to talk across-the-board popularity and box office draw or a surefire familiar face for a commercial, Lobo remains the most in-demand star in the league. It is a curious fact that the WNBA has better players but no consistently bigger name than this center and crowd favorite for the New York Liberty—even if she isn't among the top eighteen scorers in the league. Lobo's jersey is one of the WNBA's top-five sellers. Her latest endorsement is a deal with Mattel to promote the toy company's new WNBA Basketball Barbie. "When it comes to the national Q rating, Rebecca is top of the charts," says WNBA President Val Ackerman.

The onetime Connecticut star has, for lack of a better term, star quality. She's had it ever since she led the Huskies to a 35–0 season and a national championship in 1995. She was a gawky teenager, but a strangely telegenic one who helped launch the women's game into the big time. After graduation, she joined the 1996 U.S. Olympic team that won the gold medal. When the WNBA launched the next year, Lobo was one of two premier players assigned to the league's most visible franchise, the New York Liberty.

"I think people watch me to see a joy in the game." Lobo say. "When the Liberty were struggling early last season, I got letters that said, 'We aren't disappointed because you're losing, or because of how you're playing. We're disappointed because you aren't smiling.' Lobo stands up, her platform heels raising her to a full six feet seven inches, and breaks into a big grin.

selena

BY CATHERINE VÁSQUEZ-REVILLA

THE DEATH OF SELENA QUINTANILLA PÉREZ, while a great loss to the community, also brings recognition to Mexican Americans, and unity to Hispanics. Selena—the vivacious and gorgeous twenty-three-year-old undisputed Queen of Tejano—died a tragic and senseless death.

Selena was from a west-side barrio in Corpus Christi, so for many of the children from lower-income families in Corpus Christi, Selena became a symbol of hope for their own success. Her devotion and obligation to her family and community were qualities that many Hispanics consider important in their own lives. Her father, Abraham Quintanilla, was her manager and booking agent; her sister, Suzette Quintanilla Arriaga, was the drummer in her Los Dinos band; her brother, "Abe" Quintanilla Jr., was her producer, guitarist, and cowriter; and her bassist, Chris Pérez, became her husband. She was admired for remaining close with her family, and it is not uncommon for many Mexican American extended families to share in building a business or to live close to one another.

Language, style, and the Tejano sound of Selena's music were essential elements that also help the uninitiated to understand why Mexican Americans, especially young women, related to and identified with Selena and ultimately adopted her as a role model. Also, for young Hispanics, the use of the Spanish language was elevated to a level on par with English because Selena had reached the pinnacle of success in the Latin music industry. Besides her multiple awards, including one Grammy, she had become nationally famous in appearances on Mexican television networks by dancing and singing in Spanish.

The costumes and dance artistry were a source of pride for many Mexican Americans. She performed in skin-tight blue jeans, bustiers, and sequined bras and boleros that bared her brown skin. So, to Hispanics, especially the youth, this communicated—via satellite—that the color brown was sexy, trendy, and beautiful.

It is clear why thousands upon thousands of grieving fans drove from cities and towns in Mexico and Texas and waited in line for hours along the Corpus Christi sea all to enter the convention center where Selena's coffin was housed to say their final good-byes. And why many more attended impromptu memorials and religious services offered in her honor across the nation to leave messages saying, "We loved you."

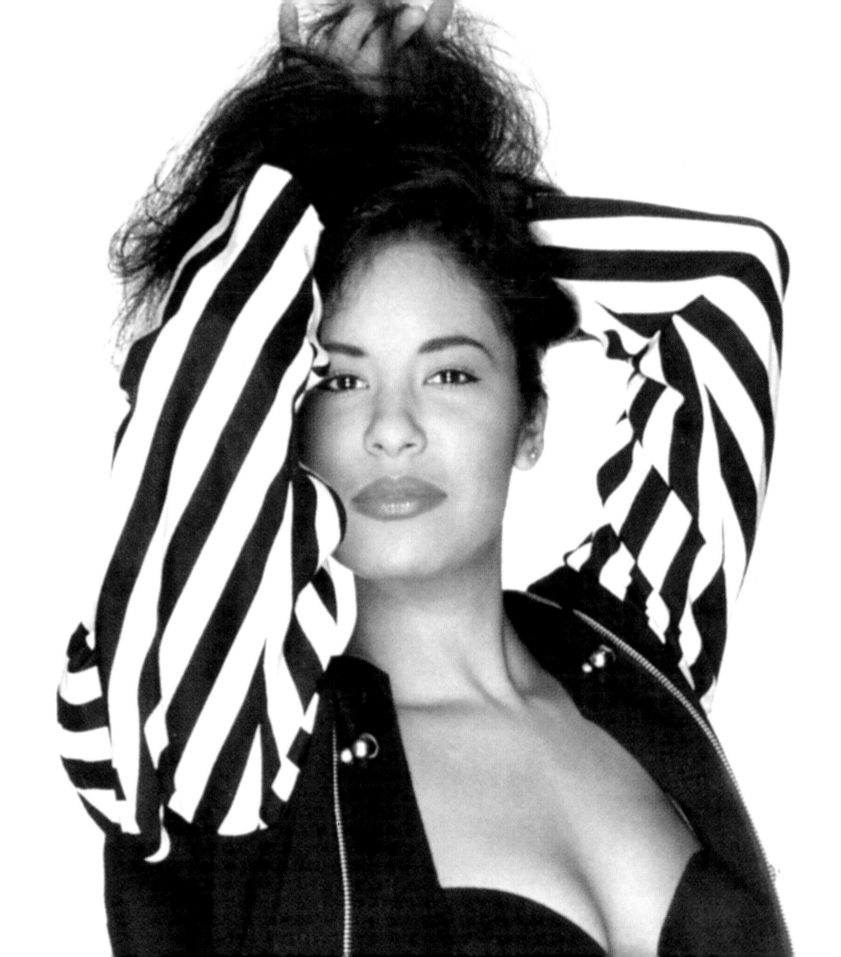

diane arbus

BY PATRICIA BOSWORTH

AS A TEENAGER, DIANE ARBUS used to stand on the window ledge of her parents' New York apartment in the San Remo, high above Central Park West. She would stand on the ledge for as long as she could, until her mother pulled her back inside. Years later, Diane would say, "I wanted to see if I could do it." And she would add, "I didn't inherit my kingdom for a long time."

Ultimately she discovered her kingdom with her camera. Her dream was to photograph everybody in the world, and by the end of the 1960s she was a legend in magazines, with edgy, transcendental photographs of peace marches, art openings, circuses, and portraits of billionaire H. L. Hunt, Gloria Vanderbilt's baby, Coretta Scott King. In them she explored the eerie visual ambiguity of twins and triplets, the distinctions—and the connections—between bag ladies and wealthy matrons. Her complex feelings about her subject matter, her terror and fascination, were often reflected in her pictures. She thought of photography as an adventure, an event that required courage and tenacity. Her camera was also, as she said, her protection, her shield.

"A photograph is a secret about a secret," she said. "The more it tells you, the less you know." This idea seemed to reverberate in her unsettling images of freaks and eccentrics, pictures that were beginning to be heralded in the art world when Diane Arbus killed herself in 1971.

Diane Arbus was born in New York City on March 14, 1923. Her mother, the beautiful Gertrude Russek Nemerov, named her after the sublimely romantic heroine of the play *Seventh Heaven.* Early on, Diane showed a talent for painting. For years, like many imaginative children of the time, she was terrified that the Lindbergh kidnapper would descend on her. Being afraid gave her pleasure, and much later she remembered that she loved to stay in her pitch-black bedroom at night waiting for monsters to come and tickle her to death. To combat frequent depressions, Diane took pictures on her own. She was too shy to ask strangers to pose, so instead she took pictures of friends. She photographed, off and on, a great many children—enraptured Puerto Rican kids watching a puppet show in Spanish Harlem; a tiny, seemingly deformed boy and girl laughing into her camera. Then there were endless candids of her two daughters, Doon and Amy.

Her importance has extended beyond photographic circles. Stanley Kubrick, the filmmaker, used her image of twins over and over again in his horror movie *The Shining.* Among many people, the phrase "an Arbus face" is synonymous with expressions of anguish, kinkiness, and, in the words of Sanford Schwartz, the critic, "a kind of creepy intimacy."

zelda fitzgerald

BY ELIZABETH HARDWICK

THE VERY CENTER OF ZELDA FITZGERALD has to do with literature, with her relations to her husband F. Scott's work and to her own writings. The most pronounced of her gifts was indeed for writing. And she had the precious gift of fantastic energy—not energy of a frantic, chaotic, sick sort, but that of steady application, formed and sustained by a belief in the worth of work and the value of each solitary self.

Zelda was a schizophrenic. Her mental confusion was sometimes alarming; she suffered, on occasion, disorientation, hallucinations, great fears, and depressions, even to the point of a number of suicide attempts. But these low periods could not have been other than transitory because her letters throughout her illness are much too lucid, controlled, alive with feeling and painful awareness. In her fight against insanity and dependency she turned, as many disturbed people turn—at least the educated ones—to the hope of release through the practice of art. There was a strangeness, not altogether promising for her, in the number of things she could do well. She practiced ballet, and in 1934, thirteen paintings and fifteen drawings were exhibited in the lobby of the Algonquin Hotel.

In 1928, she began writing short stories. Each story was written in an astonishing but hazardous burst of energy. Nevertheless, the stories were published under both Fitzgeralds' names. Then an astonishing thing happened. Zelda quite suddenly produced a finished novel, *Save Me the Waltz.* The novel is quite well written, drawing on Zelda's life, and is thus a mixture of sharply observed Southern scenes and contrasting worldliness. The institutions, asthma, eczema, guilt, loneliness: none of this had subdued Zelda's supernatural energy. She always had been able to call on it, whether for swimming, dancing, or writing. She stayed in a sanitarium for years, endured it all, always being reminded of her "limitations" and "permanent damage." She died there and left, in addition to her legend, another memorial to her unkillable energy—an unfinished novel she intended to call *Caesar's Things.*

What are we to make of all this? Zelda's letters from the hospital are clear and courageous and searing to read. She was anarchic, inspired, brilliant, unsteady, very much in her own way like the gods of the arts, like the spoiled, gifted, and famous all around her. In her, alas, the madness was real rather than an indulgence. A few years back the interest in the Fitzgeralds lay in in the tragic grandeur and glamour of their love story. Now I should think it rests entirely in the heroism of this strange, valuable girl from Montgomery, Alabama.

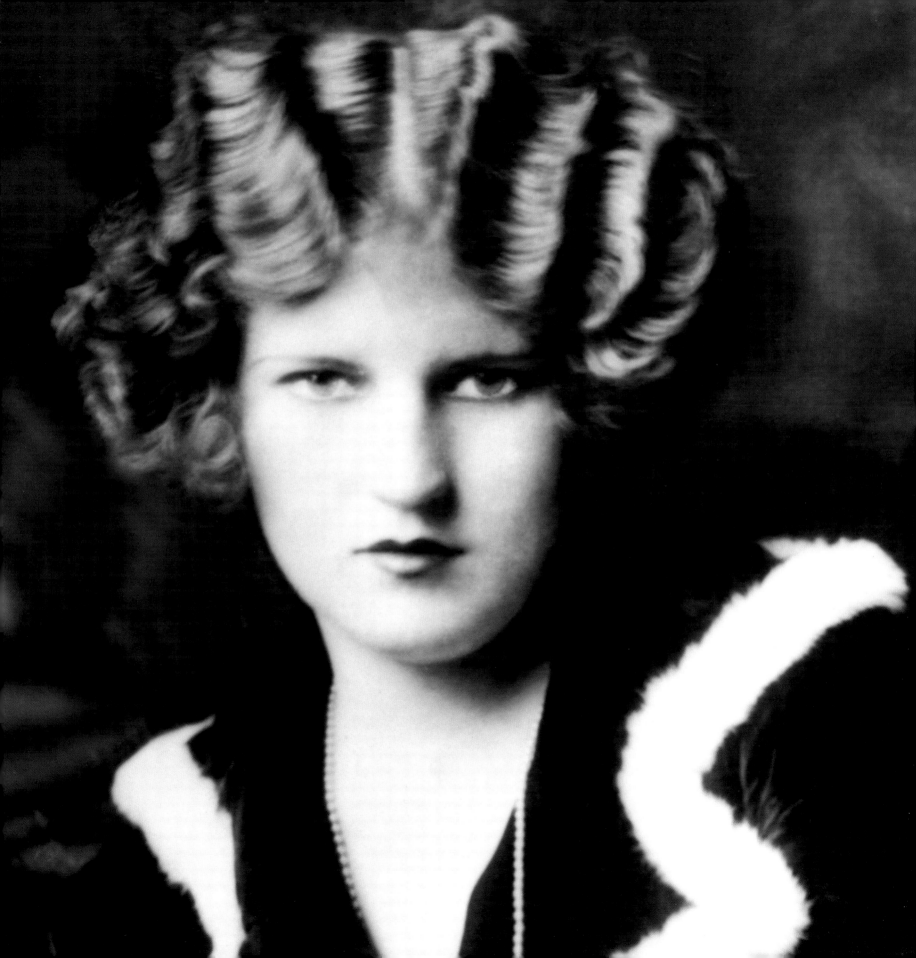

janis joplin

BY MYRA FRIEDMAN

Janis Joplin shot out of Port Arthur, Texas, as a teenager in the late fifties and, via Austin, blasted out west to San Francisco, where she became part of one of the most musically exciting and creative periods in this country's cultural history. Born in the idealism of the early sixties and taking its heat from the passions of the civil rights movement, it was an era that forged its spiritual alliance with the rising expectations of black America and gave birth to an amplified music that rose righteously up from a boundless love for the blues. Say what you will about the fire and fury of that decade, it yielded a glorious time in popular music and, through the fantastic energies and enthusiasms it set loose, brought to flower a prideful, inspired, authentic American art form. Jimi Hendrix was its most brilliant musician; the talent of Janis Joplin was its gorgeous light.

On October 4, 1970, Janis Joplin died in a Hollywood motel. The cause of her death was an overdose of heroin boosted by too much booze. She was a rock 'n' roll woman to her toes, a blues singer of unparalleled passion, and the greatest female performer to emerge from the tempest of the late 1960s. Ecstatic on stage and emotively sublime, she went through life like a superbly visible comet streaking across the sky: quick, brilliant, gone. More than any performer of her day, she symbolized the mental condition of the decade that molded her genius, and out of its theatricalities, its eye-popping colors, its peaks, its overdrive sex, its impatience, its excitements, and, dammit, its dangers, too, she made of herself a complete and dazzling original. Janis's death marked the final seizure of a fevered era, which had subsisted on an energy so violent that it would, by necessity, be doomed to end only in self-immolation.

Janis's style flipped the country on its ear. With bracelets racing up and down her arms, love beads, sandals, bell-bottoms (she finally pitched the white dress), and a cascade of wildly electric uncombed hair, she burst historical boundaries with a determination, a ballsiness, and a sexual bravado that no woman (surely not from an American middle-class background, anyway) had ever displayed so openly, or not quite like that. She had the look of a pioneer; her gaze was strong, her demeanor proud (at least when she was sober). In one knockout package, she swooped right down on the land as America's most conspicuous challenge to traditional notions of femininity. And she seemed, anyway, to embody the very essence of freedom and eternal devotion. Janis Joplin didn't have to be any ally of the women's movement—which in its early days was too fractious for her—to be an inspiring symbol.

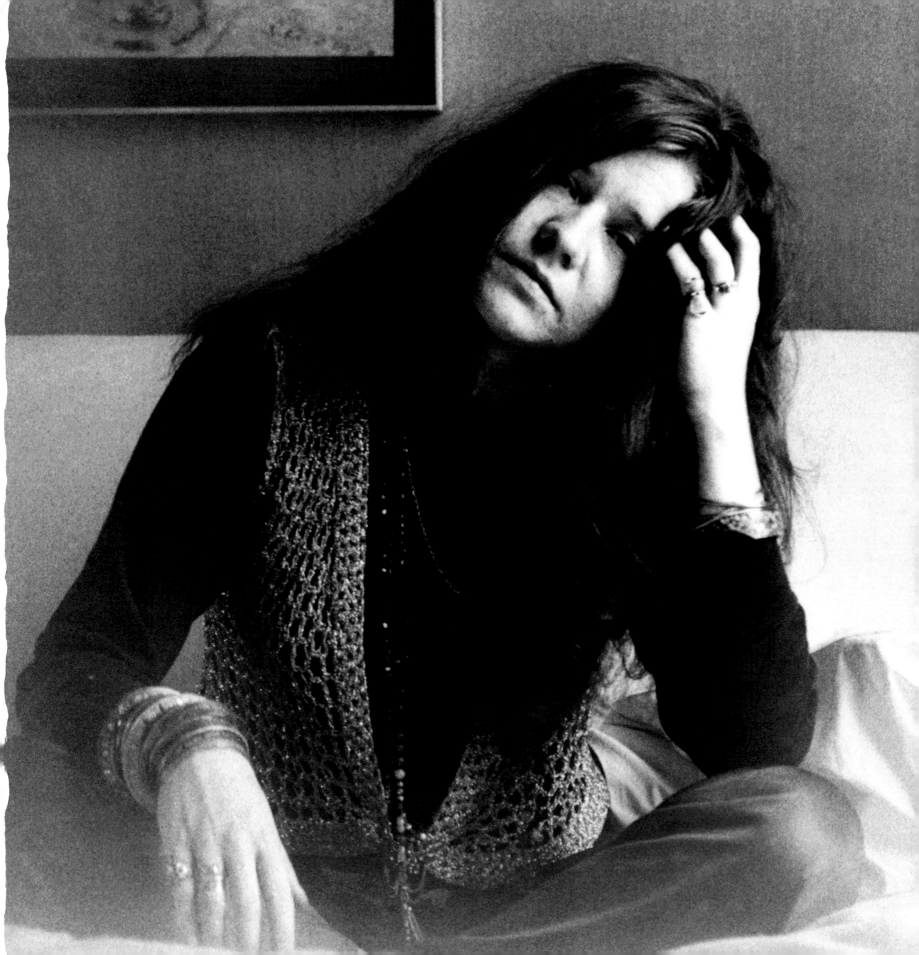

biographies

christiane amanpour,
CNN's chief international correspondent, has reported on crises from Afghanistan, the Balkans, Iran, Iraq, the Middle East, Pakistan, and Somalia. She has received wide acclaim for her extensive reports on the conflict in Yugoslavia, as well as the Bosnian tragedy.

sherry ricchiardi
is a contributor to *American Journalism Review* and an associate professor at the University of Iowa.

Photo: CORBIS

Page 20

diane arbus's
unflinching portraits of people on the edge of society redefined the idea of documentary photography. Her controversial images of dwarfs, twins, and transvestites were the precursor to much of today's documentary and fashion photography. Arbus committed suicide in 1971.

patricia bosworth
is the author of biographies on Montgomery Clift, Marlon Brando, and Diane Arbus.

Photo: STEPHEN FRANK

Page 104

candice bergen
is the daughter of popular radio ventriloquist Edgar Bergen. She was a child actor and then starred in a series of critically acclaimed films, including *The Sand Pebbles, Carnal Knowledge,* and *Starting Over.* From 1988 to 1998, she starred in *Murphy Brown,* a role that won her multiple Emmy Awards.

judith newman
writes for numerous magazines, including *Vogue* and *Ladies' Home Journal,* from which this piece is taken.

Photo: CORBIS

Page 42

halle berry,
a former teenage beauty queen, has starred in numerous films, including *Swordfish,* and *Die Another Day.* She was the first African American woman nominated for an Academy Award for her role in *Introducing Dorothy Dandridge;* she was the first to win for *Monster's Ball.*

amy fisher
writes regularly for entertainment magazines, including *Self* and *Details.*

Photo: CORBIS

Page 28

ingrid betancourt,

Colombian senator,
bestselling author, and
presidential candidate, has
been outspoken on the taboo
topics of drug trafficking,
political corruption, and
how to fix democracy in
her nation. Betancourt was
kidnapped by leftist guerrillas
in 2002.

dinitia smith

is a reviewer and critic for the
New York Times. Her profile of
Ingrid Betancourt appeared in
February 2002.

Photo: CORBIS

Page 78

cate blanchett

was born in Melbourne,
Australia. After a successful
theatre career, she made her
film debut in 1997 in *Paradise
Road* and *Oscar and Lucinda.*
In 1998, Blanchett won a
Golden Globe for her
portrayal of England's queen
in *Elizabeth.* Since then, she's
appeared in *The Talented Mr.
Ripley, Bandits, The Shipping News,*
and *The Lord of the Rings*
trilogy, among many others.

melissande clarke

is also from Australia and
writes on popular culture
for a variety of magazines,
including *Los Angeles,* from
which this excerpt is taken.

Photo: CORBIS

Page 98

maria callas

made her operatic debut in
Athens in 1938. Her career
blossomed in the 1940s; from
then on, she was praised for
her beautiful soprano voice,
as well as her amazing sense
of drama. The latter spilled
into her private life, including
a long liaison with Greek
shipping magnate Aristotle
Onassis.

holly brubach

received a National Magazine
Award in 1982 for her dance
criticism in the *Atlantic
Monthly.* Her most recent book
is *A Dedicated Follower of Fashion.*

Photo: CORBIS

Page 86

evelyn cisneros

was the first Hispanic prima
ballerina in the history of
ballet in the United States.
During her twenty-two year
career with the San Francisco
Ballet, she was revered for her
legendary power and grace.
She charmed even the critics;
a 1997 *Dance* magazine
interviewer asserted, "leaving
Cisneros is like a rude
awakening."

stephanie von buchau

writes regularly for *Hispanic*
magazine. Her profile
of Evelyn Cisneros was
published in 1989.

Photo: SAN FRANCISCO
BALLET

Page 82

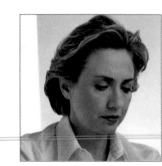

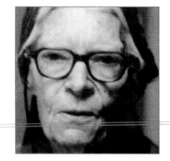

patsy cline

was the first woman introduced into the Country Music Hall of Fame. Her string of hits included "Walkin' after Midnight," "I Fall to Pieces," and Willie Nelson's "Crazy." In 1963, Cline's budding career was tragically cut short when she was killed in a plane crash at age thirty.

roseanne cash

is a country music singer and daughter of Johnny Cash. She wrote about Patsy Cline for the *New York Times Magazine*.

Photo: CORBIS

Page 94

hillary clinton

the senator from New York, was First Lady to President Bill Clinton. During her tenure, she emerged as the dynamic partner of her husband, and the president named her to head the Task Force on National Health Reform. Her recent memoir of her time in office, *Living History*, is an international bestseller.

gail sheehy

is the author of *Passages* and a regular contributor to *Vanity Fair*.

Photo: ANNIE LEIBOVITZ

Page 56

jamie lee curtis

is the daughter of screen legends Tony Curtis and Janet Leigh. She has starred in numerous films, inding *Halloween*, *A Fish Called Wanda*, *True Lies*, and *Freaky Friday*. She is also the author of the best-selling children's books *Tell Me Again about the Night I Was Born*, and *When I Was Little: A Four-Year-Old's Memoir of Her Youth*.

maria shriver

is a contributing anchor for *Dateline NBC* and a correspondent for MSNBC. In 2003 she became First Lady of California.

Photo: CORBIS

Page 58

dorothy day

was a radical activist who turned Catholic in 1927. With Peter Maurin, she founded the Catholic Worker movement, devoted to aiding the poor through hospitality houses. Her devotion to the underprivileged led her to be widely regarded as a modern-day saint. Day's writings include her autobiography, *The Long Loneliness*.

beth randall

writes for the Drexel University website, where this essay on Dorothy Day appeared.

Photo: MARQUETTE UNIVERSITY

Page 74

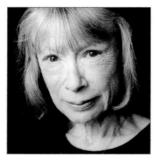

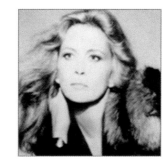

joan didion

one of the pioneers of the 1970s New Journalism, is the author of *Play It As It Lays*, *Slouching Towards Bethlehem*, and *Salvador*. Her colorful, personal essays are set against a backdrop of disintegrating mores in the United States and abroad. Didion often collaborated with her husband, John Gregory Dunne, who died in 2003, on screenplays.

susan orlean

is the author of *The Orchid Thief* and a regular contributor to the *New Yorker*. Her profile of Didion appeared in *Vogue*.

Photo: Corbis

Page 26

faye dunaway

has starred in dozens of films over the last thirty years, first as Bonnie Parker in *Bonnie and Clyde*, then in *Three Days of the Condor*, *The Thomas Crown Affair*, and *Chinatown*, among others. The prolific actress received an Academy Award for her role in the 1976 classic *Network*.

joan juliet buck

has written extensively on culture for *Vogue*, *Vanity Fair*, and the *New Yorker*.

Photo: Corbis

Page 80

nora ephron

is a former magazine writer turned Hollywood writer, director, and producer. Her unique, laid-back, conversational writing style has made hits of her films *When Harry Met Sally*, *Sleepless in Seattle*, *You've Got Mail*, and *Michael*.

dinitia smith

is a regular reviewer and critic for the *New York Times*. Her profile of Ephron appeared in February 2002.

Photo: Corbis

Page 84

carly fiorina

has been named the most powerful woman in American business by *Fortune* magazine. In 1999, she was named president/CEO of Hewlett Packard, one of the world's largest technology companies. Previous to HP, she was president of Lucent's Global Service Provider division.

elizabeth brandt

profiles top executives for the business magazines *Research* and *Buyside*.

Photo: Corbis

Page 66

zelda fitzgerald

is thought to have co-authored many short stories attributed to her husband, F. Scott Fitzgerald. She is also the author of letters and short stories under her own name, all assembled in *The Collected Writings of Zelda Fitzgerald.* Her novel, *Save Me the Waltz,* is considered her masterpiece.

elizabeth hardwick

is the author of numerous books of literary criticism. She also cofounded and contributes regularly to the *New York Review of Books.*

Photo: CORBIS

Page 106

cathy freeman

is a world-class sprinter who represented Australia in the 2000 Olympic games. A native Aborigine, she was privileged to carry the Olympic torch its final leg, lighting the cauldron while four billion people looked on.

sarah goldman

is a writer for sports magazines, including *Sports Illustrated* and *Runner's World.*

Photo: CORBIS

Page 44

terry gross

is the host of NPR's *Fresh Air,* an interview program featuring a dizzying variety of guests. Gross's highly personal, straightforward style has become a model for many journalists. Each week nearly four million people tune in to the show's intimate conversations broadcast on 414 NPR stations across the country.

orna feldman

writes for numerous magazines and newspapers including the *New York Times, Soundings,* and *American Journalism Review,* from which this excerpt is taken.

Photo: WHYY

Page 30

zaha hadid

was born in Baghdad in 1950. The winner of numerous architectural awards, her work is universally praised but rarely built. A recent exception is the widely admired new Contemporary Arts Center in Cincinnati. Hadid's work is part of the permanent collection of the Museum of Modern Art, New York. In 2004 she became the first woman to win the prestigious Pritzker Award.

kelly beamon

writes on art and architecture for *Imprint* and *Architecture.*

Photo: ZAHA HADID ARCHITECTS

Page 40

eva hesse

and her family escaped Nazism and emigrated to New York City, where she attended Pratt Institute. Originally a painter, she gained acclaim for her organic surrealistic sculptures. Her career was abruptly cut short by a fatal brain tumor.

dodie kazanjian

is the author of books and articles on art and artists, including *Alex: The Life of Alexander Liberman* and *Icons: The Absolutes of Style*.

Photo: STEPHEN KORBET

Page 54

chrissie hynde

is the lead singer/songwriter for the Pretenders, the post-punk band she founded in the late 1970s. Her unflinching style and personal writing have made her an icon for women musicians over the past three decades. Hynde is also an active spokesperson for People for the Ethical Treatment of Animals.

evelyn mcdonnell

writes regularly on music for many publications, including the *Miami Herald*, from which this excerpt is taken.

Photo: CORBIS

Page 52

bianca jagger

used to be known merely as Mick's wife. But since their divorce, she has spent her time rescuing children, traveling as a goodwill ambassador, and speaking out about human rights around the globe, from Bosnia to Central America.

irene middleman thomas

writes regularly for *Hispanic* magazine.

Photo: CORBIS

Page 70

norah jones's

debut album *Come Away with Me* won a record five Grammys at the 2002 awards. The daughter of Ravi Shankar, Jones's astounding crossover style is a blend of smooth pop crooning and jazz, the mainstay of her label, Blue Note.

katherine tradd

reviews music for daily and weekly newspapers in Southern California.

Photo: CAPITOL RECORDS

Page 16

janis joplin's freewheeling, boozy style was emblematic of late '60s rock. She was inspired by Ledbelly and Bessie Smith, and her gravelly voice and blatant sexuality supercharged hits like "Me and Bobby McGee" and "A Piece of My Heart."

myra friedman is the author of *Buried Alive: The Biography of Janis Joplin*, from which this excerpt is taken.

Photo: CORBIS

Page 108

barbara jordan served in the U.S. House of Representatives from 1972 to 1976. She captivated the nation during President Richard Nixon's impeachment hearings with her oratorical ability. Jordan was the first Southern African American woman in the House.

molly ivins is a nationally syndicated columnist whose work has appeared in *Esquire*, the *Atlantic*, the *Nation*, *Harper's*, and *TV Guide*.

Photo: CORBIS

Page 88

donna karan is the founder and CEO of Donna Karan New York, DKNY, and ready-to-wear collections, as well as Donna Karan eyewear, hosiery, furs, shoes, perfume, and home furnishings. Since 1984, the company has grown from a small clothing line into a $100 million business.

stephanie mansfield is the author of *The Richest Girl in the World*. She writes for *Elle* and *Vogue*.

Photo: DONNA KARAN, INC.

Page 24

diane keaton's career took off with her portrayal of Annie Hall in the Woody Allen classic. After winning the Academy Award for Best Actress, she went on to star in dozens of films, including *Stardust Memories*, *Hanging Up*, *The Godfather*, *Reds*, and *Something's Gotta Give*, for which whe received a Golden Globe Award and an Oscar nomination.

sara kinsell profiles artists for *New York* magazine.

Photo: BRIGITT LaCOMBE

Page 64

nicole kidman

is acclaimed for her acting versatility. In the past ten years, she's starred in films as disparate as *Eyes Wide Shut*, *Batman Returns*, *The Peacemaker*, *To Die For*, and *The Hours*, in which her portrayal of Virginia Woolf won her an Oscar.

dorothy summers

writes for numerous city and entertainment magazines, including *San Francisco*, from which this excerpt is taken.

Photo: CORBIS

Page 38

ann landers

was perhaps the most famous syndicated columnist in history. Her advice column, which she took over in 1955, eventually appeared in more than 1,200 newspapers in the United States, with a readership of over ninety million. When she died in 2002, the column was retired.

margalit fox

is a writer for the *New York Times*. This excerpt is from her 2002 obituary of Landers.

Photo: CORBIS

Page 72

k. d. lang's

sultry crooning and androgynous persona have captivated the music world over the last twenty years. Her unique country-pop-rock records have earned her comparisons to a wide range of music idols, from Madonna to Mick Jagger to Elvis.

leslie bennetts

writes about music for numerous publications, including *Vanity Fair*, the *New York Times*, and *Rolling Stone*.

Photo: MATTHEW ROLSTON, CORBIS

Page 68

jessica lange

was one of literally hundreds of women who auditioned for the female lead in the 1976 big-budget remake of *King Kong*. Director Dino De Laurentiis chose her, and a star was born. Her roles in *The Postman Always Rings Twice*, *Frances*, *Blue Sky*, *Hush*, and *Country* won her critical acclaim; her role in *Tootsie* won her an Oscar.

marina carroll

writes Hollywood profiles regularly for *San Francisco* and *Diablo* magazines.

Photo: CORBIS

Page 90

queen latifah,

or Dana Owens, is a rapper, record producer, and actress. She is best known for her million-selling release *All Hail to the Queen* and her acting parts in *Chicago, Jungle Fever, Bringing Down the House, The Bone Collector,* and *Living Single.* She is also the CEO of a record company, Flavor Unit.

deborah gregory

contributes regularly to *Essence.* She wrote this piece for its twenty-fifth anniversary issue.

Photo: FRED OCKENFELS

Page 32

nigella lawson

is the star of the wildly popular *Nigella Bites,* the sexiest cooking show in history. She is also the author of three cookbooks, *How to Be a Domestic Goddess, Nigella Bites,* and *Forever Summer.*

lynn hirschberg's

famous interviews and profiles have appeared in *Rolling Stone, New York, Vanity Fair,* and the *New York Times Magazine,* where she is a contributing writer.

Photo: CORBIS

Page 34

rebecca lobo

has been the most popular player in the WNBA since the league's inception. She was one of the league's first players and first all-stars. She continues to be a driving force behind the New York Liberty, her current team.

sally jenkins

is a sports columnist and feature writer for the *Washington Post.*

Photo: KENTON EDELIN

Page 100

toni morrison

is a writer, teacher, and editor. Her highly acclaimed novels include *Jazz, Sula, The Bluest Eye, Beloved, Song of Solomon, Paradise,* and *Love.* In 1993, she was awarded the Nobel Prize in Literature; she was the first African American and only the eighth woman to be named a Nobel Laureate.

claudia dreyfuss

writes regularly for the *New York Times Magazine,* from which this excerpt is taken.

Photo: ANNIE LEIBOVITZ

Page 18

eleanor holmes norton
is a lawyer and civil rights
activist. She is former assis-
tant director of the American
Civil Liberties Union, head of
New York City's Human
Rights Commission, and chair
of the U.S. Equal
Employment Opportunity
Commission. In 1982, she
became a law professor at
Georgetown University.

coretta scott king,
widow of Martin Luther King
Jr., has a distinguished career
in activism and helped pass
the 1964 Civil Rights Act.

Photo: DAVID SHARPE

Page 50

bonnie raitt
learned guitar when she was
twelve, inspired by blues
musicians Mississippi Fred
McDowell and Buddy Guy.
She was widely popular in
the 1970s for her earthy
rhythm-and-blues rock, and
her albums *Nick of Time* and
Luck of the Draw were the
cornerstones of her 1990s
comeback.

mary paulson
writes regularly on music.
Her work has appeared in
San Francisco, Rolling Stone, and
Equator.

Photo: EMI MUSIC

Page 76

j. k. rowling
penned the first Harry Potter
novel while struggling to sup-
port her daughter and herself
on welfare. After a number of
rejections, she finally sold
*Harry Potter and the Sorcerer's
Stone.* The first three Harry
Potter books earned $480
million, with over thirty-five
million copies in print. Most
recently, readers around the
globe camped out to be first
in line for *Harry Potter and the
Order of the Phoenix,* the fifth
book in the series.

linda richards
is the editor of *January*
magazine.

Photo: CORBIS

Page 92

selena's
remarkably successful pop
career was cut short by her
tragic murder. Selena's infec-
tious Latin pop earned her
critical and fan accolades.
As the first Latin artist signed
to EMI International, she
won the Tejano Music Award
for Female Vocalist of the
Year ten times.

catherine vásquez-revilla
is a regular contributor to
Hispanic magazine.

Photo: EMI LATIN

Page 102

bessie smith

began her career working for her mentor, Ma Rainey. Known as "the Empress of the Blues," Smith belted out hit after hit for over forty years. She became the prototype big female blues singer, a woman who lived a life hard enough to *really* sing the blues.

susannah mccorkle

was acclaimed as one of the most popular jazz-pop vocalists of recent times. She was also an accomplished writer of both fiction and nonfiction. She died in May 2002.

Photo: CORBIS

Page 96

twyla tharp,

choreographer and modern dancer, was trained in ballet and dance and performed with the Paul Taylor Dance Company before forming her own company. She has choreographed pieces for leading ballet companies and published an autobiography, *Push Comes to Shove.*

holly brubach

received a National Magazine Award in 1982 for her dance criticism in the *Atlantic Monthly.* Her most recent book is *A Dedicated Follower of Fashion.*

Photo: TWYLA THARP STUDIO

Page 48

mitsuko uchida

began studying piano in Vienna when she was twelve. Today, she is considered the top female classical pianist in the world, known for her sustained, whispered tones and her original interpretations of such masters as Schoenberg and Schubert.

katherine ames

writes regularly for *Time* magazine, from which this excerpt is taken.

Photo: AOL TIME WARNER

Page 60

alice walker

has won acclaim for her poetry and fiction, notably *The Color Purple*, for which she won the Pulitzer Prize in 1983. Her other novels include *The Temple of My Familiar* and *Possessing the Secret of Joy;* her most recent book of poetry is *Absolute Trust in the Goodness of the Earth.*

alexis de veaux

is the author of *Don't Explain,* a biography of Billie Holiday.

Photo: MICHAEL COLLOPY

Page 62

barbara walters

began her career by writing for CBS's *Morning Show.* She then moved to NBC, where she became a staple at *Today.* She remained on the show for eleven years, then debuted as the first woman coanchor of a network evening news program in 1976. The same year, she launched the first *Barbara Walters Special* and eventually her post-Oscar interview program.

jennet conant

writes for many national magazines and is the author of *Tuxedo Park.*

Photo: CORBIS

Page 36

vera wang

is a bridal-wear designer who has transformed brides from staid to sexy. Her clients include Sharon Stone, Uma Thurman, and Mariah Carey. Her company has now branched into other design, including evening wear, shoes, handbags, eyewear, and crystal and china.

lynda richardson

writes on fashion and style for the *New York Times.*

Photo: NIGEL BARKER

Page 14

alice waters

opened the Berkeley restaurant Chez Panisse in 1971 and changed food forever. Her emphasis is on the highest-quality products and the freshest ingredients, only when they are in season. She continues to be a strong advocate of farmers' markets and sustainable agriculture.

marian burros

is a regular contributor to the *New York Times*.

Photo: CORBIS

Page 46

raquel welch,

originally Jo Raquel Tejada, was the ultimate 1960s sex symbol. This role, which was fueled by her scantily clad appearance in *One Million Years B.C.*, persisted through the decade. In an effort to shed the image, Welch starred in *Myra Breckenridge* and then won a Golden Globe for *The Three Musketeers*. Welch also had success in the Broadway musical *Woman of the Year*.

joanne kaufman

writes for the *Wall Street Journal*, where this piece appeared.

Photo: CORBIS

Page 22

venus and serena williams

are the most dominant duo in the history of women's tennis. Currently ranked among the top seeds in the country, they routinely square off against each other in tennis's major events.

andrea leand

writes regularly on sporting events for *Sports Illustrated* and *Sport*, from which this excerpt is taken.

Photo: ANNIE LEIBOVITZ

Page 12

permissions
acknowledgments

 NEW WORLD LIBRARY is dedicated to
publishing books and audio products that inspire and challenge us to
improve the quality of our lives and our world. Our products are
available at bookstores everywhere. For a complete catalog, contact:

New World Library
14 Pamaron Way
Novato, California 94949

Phone: (415) 884-2100
Fax: (415) 884-2199
Or call toll free: (800) 972-6657
Catalog requests: Ext. 50
Ordering: Ext. 52
Email: escort@newworldlibrary.com
www.newworldlibrary.com